The Art of Reading

Lawrence Schwartzwald

The Art of Reading

Steidl

This book is dedicated to the English teachers

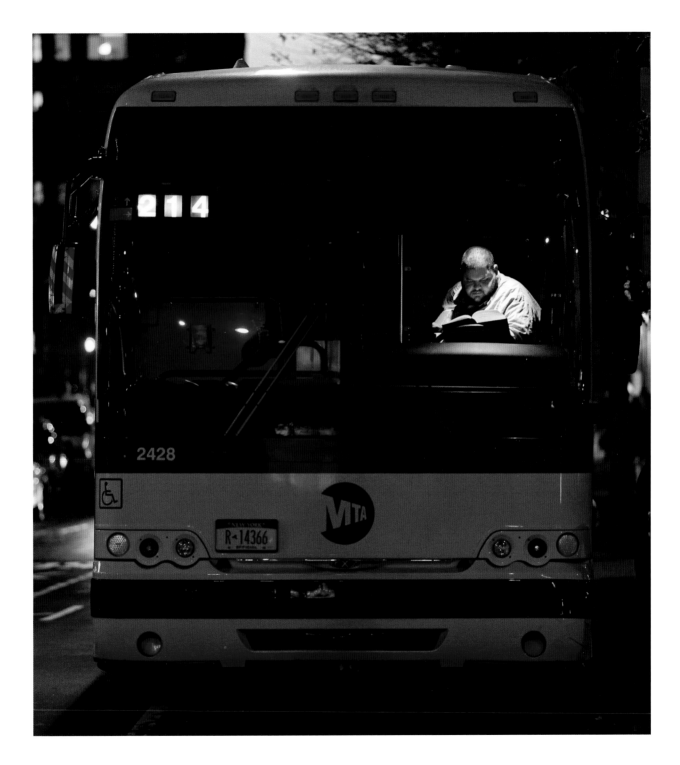

These photographs are my search for a reading nirvana

How does one measure the phantasms of influence?

Back in the early '70s, probably 1971 or 1972, I picked up a copy of André Kertész's *On Reading*, which was recently published, and I was impressed by and a bit envious of his black-and-white photographs of people in different cities around the world in the act of reading. Kertész (1894–1985) was a native of Hungary, but he also lived in Paris and New York where he created many of his images, and he travelled to and photographed his subjects in Venice, Tokyo, Manila, Buenos Aires and more. *On Reading* was first printed in '71, coincidentally the same year Diane Arbus (1923–71) took her own life at the age of 48. Her posthumous collection of images of unconventional, marginal subjects (a Jewish giant with his family, nudists, dwarves, transvestites), titled *Diane Arbus: An Aperture Monograph*, was published a year later to coincide with a retrospective exhibition at the Museum of Modern Art. In 1971 I was eighteen, had just quit my sophomore year at college in New York and was surviving, temporarily, working as a waiter at Stark's Diner at the corner of 90th Street and Broadway on the Upper West Side. I started my shift each morning, five days a week, at 7 a.m., at about the same time a dozen or so "regulars," seniors who were mostly stylish elderly women, began sauntering in to claim their favorite tables. They were witty, dignified retirees (many were widowed) and would usually linger, alone or in small groups, for hours, often ordering only a side of toast or an English muffin and cup of coffee, taking advantage of the unlimited free refills. One of the "regulars" was an affluent-looking senior with a basket of brown hair and a fixed, melancholy frown who didn't socialize and spoke in a soft pleasant whisper. "Oatmeal." Her lips barely moved and she uttered those two syllables as if they were one, each morning, no exceptions, five days a week. I don't recall her murmuring another word, but I suppose she

must have. After a few months I left the diner, briefly travelled on my own to Europe (Paris, Amsterdam, Copenhagen), and when I returned, hustled from job to crappy job before I enrolled at New York University, eventually moving into an undergraduate dorm steps away from Washington Square Park. The landmark Strand Bookstore (imagine an indoor book mall in a secular version of St. Patrick's Cathedral) was nearby and I was there so often it became a surrogate home. I was a voracious reader then and I loved to walk—to take "grand obsessional walks" (to quote Henry Miller)—across Manhattan. And I was always observing, eavesdropping, stopping at a café or the long counter of a coffee shop now and then to read James Baldwin, Knut Hamsun, Kafka, Jack London, the short stories of Isak Dinesen and Flannery O'Connor. I was fairly ignorant about photography in those days and didn't own a camera, but in the late '70s I was eager to see for myself what all the fuss about Diane Arbus was about, so I plunked down the $12.50 for a paperback edition of the *Monograph*. I turned the unnumbered pages reverently, doting over each of her gutsy images, marvelling at a visual artist whose superior intuition seemed to border on the clairvoyant. But one among the series of eighty portraits (the fifteenth) startled me; I recognized a familiar face—the fragile sullen visage of my erstwhile customer. In Arbus' square (8 ½ × 8 ½) black-and-white photograph captioned "An elderly couple on a park bench, N.Y.C., 1969," she is wrapped in an elegant sheep's wool coat with roomy sleeves and her brown eyes appear troubled and downcast. The dark brim of a mink hat, like a bleak halo, crowns her thick, well-organized mass of hair. She is clasping her hands together through the straps of a shiny black handbag and is holding onto the cord handle of a shopping bag. Her stout, mostly bald companion has a calm demeanor and is sitting close beside her. He is wearing a simple suit, a white shirt and patterned, narrow tie. His left elbow is resting nonchalantly on top

of the bench, touching her right shoulder; his left hand supports the back of his large head, which is tilted in her direction. They are both looking around, seemingly unaware of the photographer. I recall staring at the image for a long time, spellbound, trying to fathom its understated message (if any), and feeling oddly confident and inspired by the odd juxtaposition of art and real life.

Much later, in the early '90s—still reading a lot, mostly short stories and prose poems—I began to photograph (as an amateur) poets and writers at reading events around the city—Allen Ginsberg, Gwendolyn Brooks, Denise Levertov and others. I had some encouragement and picked up a better camera, and after a few weeks my first published photo ran on page one of the *New York Times*—a "weather photo" during a heat wave on July 10, 1993. A few weeks later the *New York Post* ran a celebrity photo of mine (Marisa Tomei made up to look pregnant on the film set of *The Paper*) and for the next twenty years I worked as a freelance photojournalist. I continued to read, mostly poets. Now and then I would snap a literary figure or an image of someone (sometimes a celebrity) reading a book, newspaper or other printed matter, and in 2001 my candid image of a book vendor, with a scandalous bit of derrière exposed, reading one of his own books for sale beside a cardboard sign that read "ROMANCE BOOKS 1.00" on Columbus Avenue, made a minor sensation. It ran large in the *New York Post* and soon after a reporter for the *New York Observer* wrote a hilarious column ("Wisecracking on Columbus Avenue," July 23, 2001) about the image after interviewing the "portly peddler." Since then I have continued to seek out the readers—despite (and sometimes because of) the shuttering of bookshops and the rapid growth of the Web and impersonal electronic reading devices—and to discretely photograph my subjects—mostly solitary and often incongruous, desperate or vulnerable—engaged in what seems to be a vanishing art—the Art of Reading.

Lawrence Schwartzwald

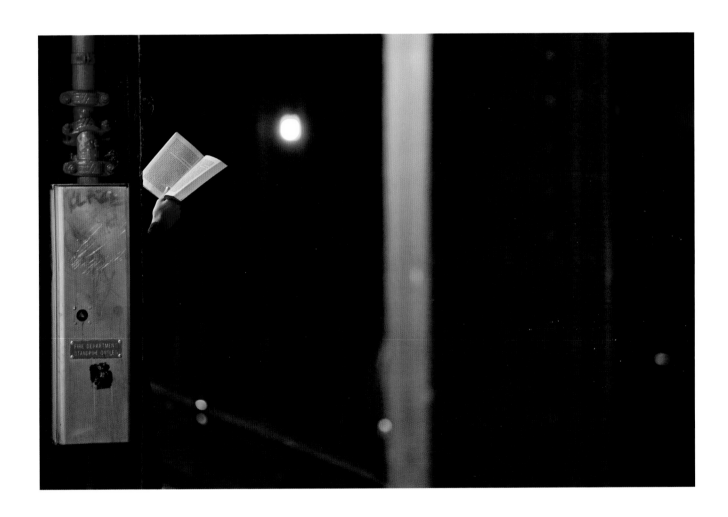

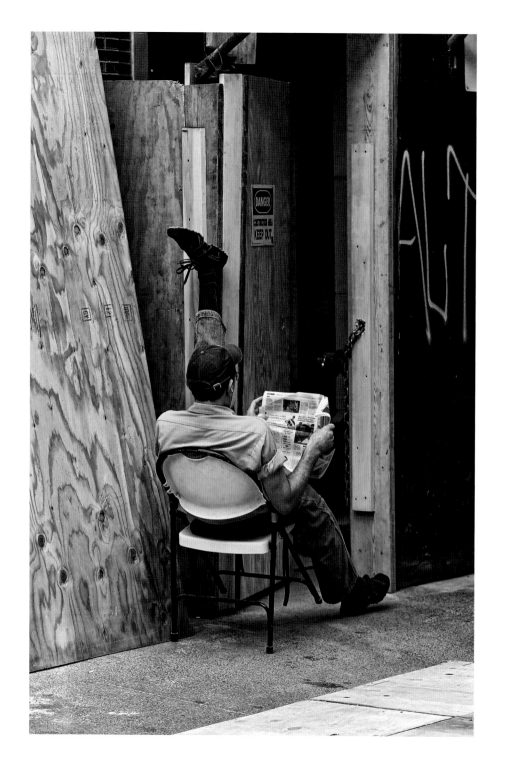

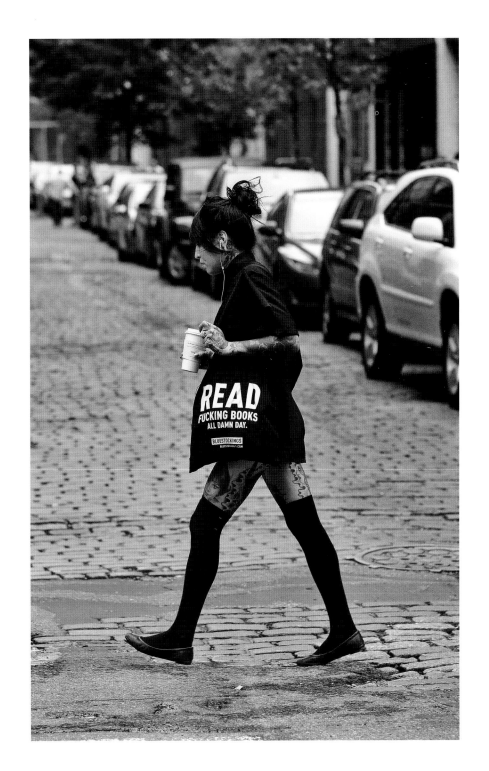

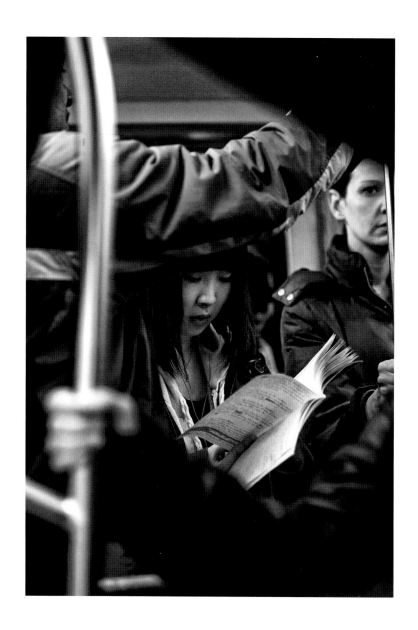

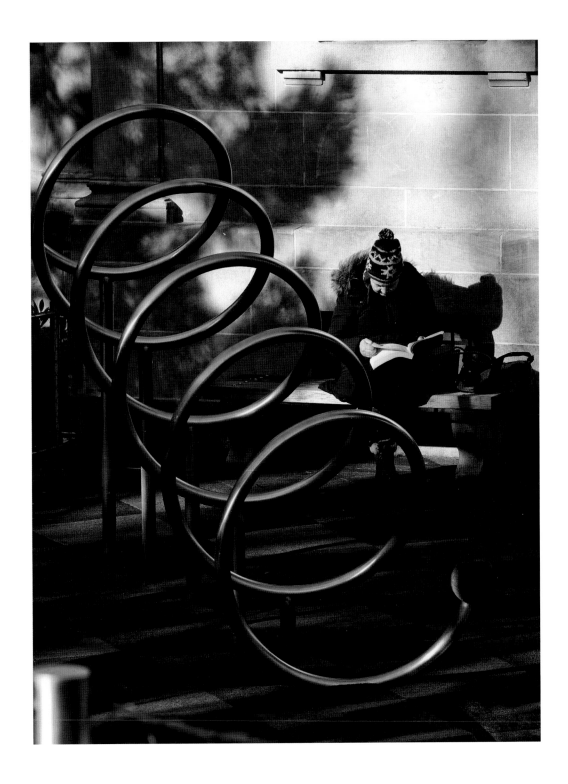

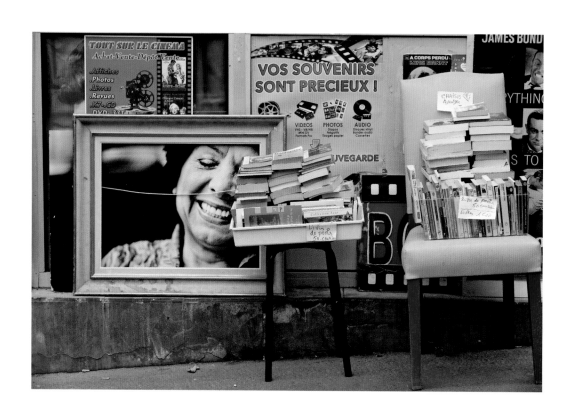

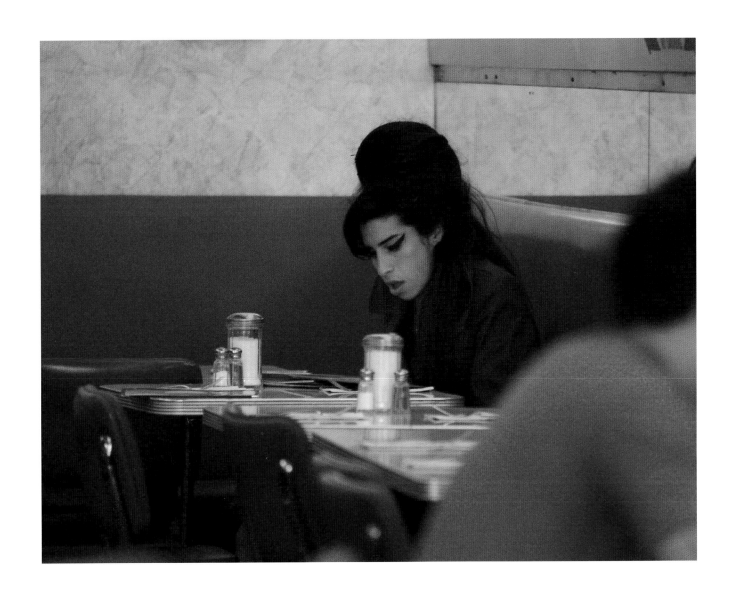

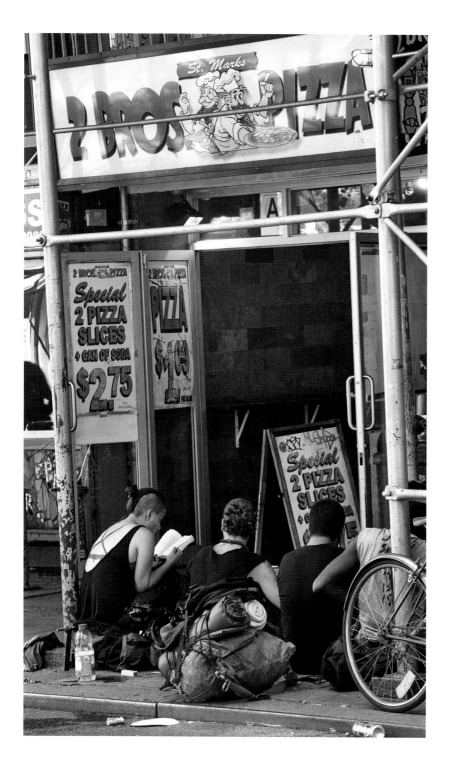

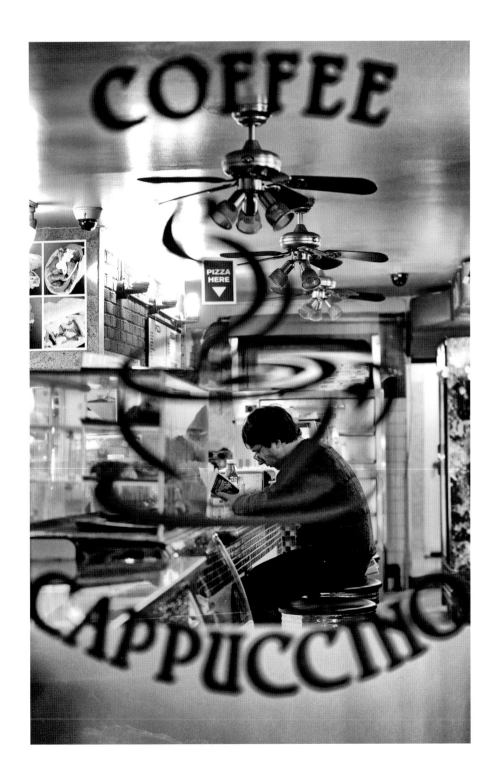

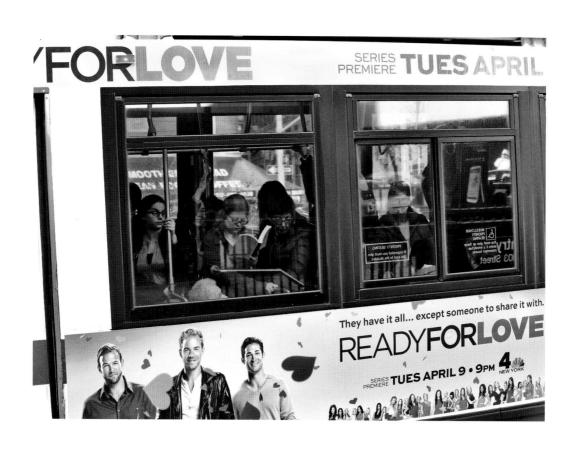

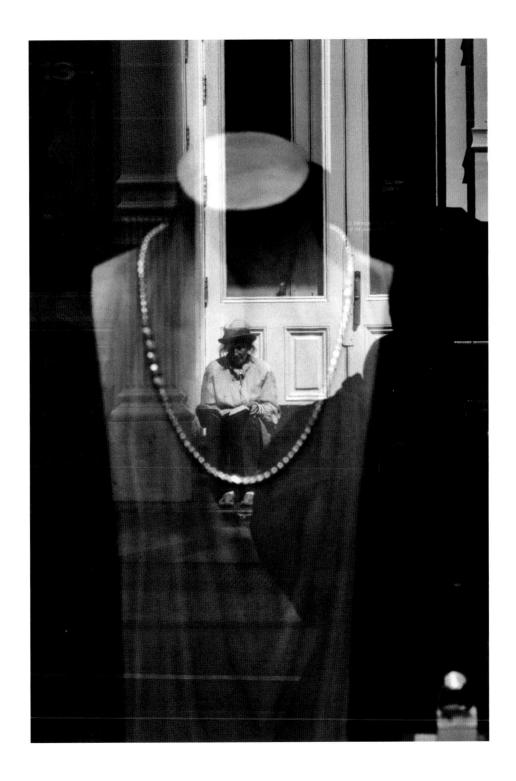

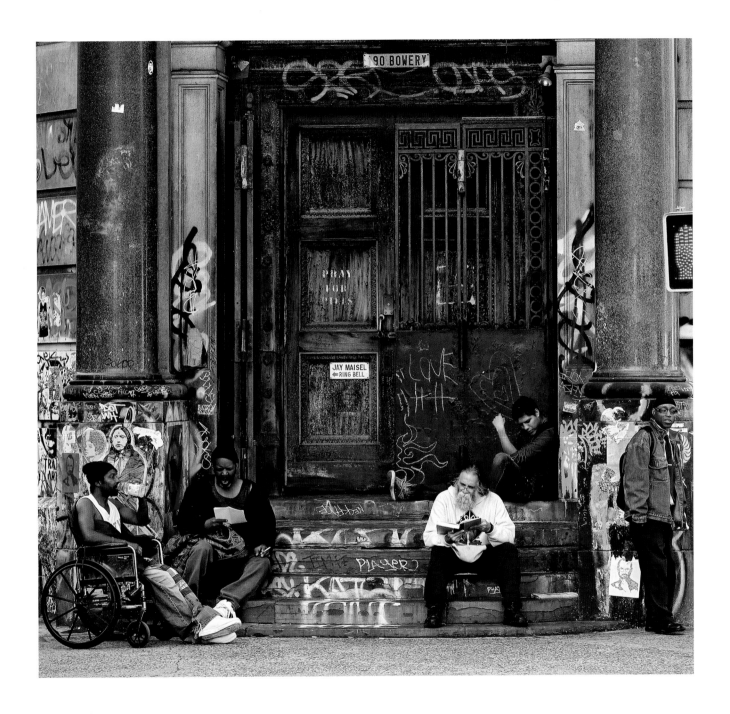

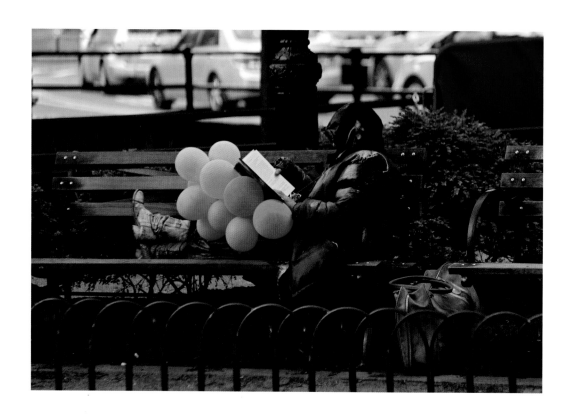

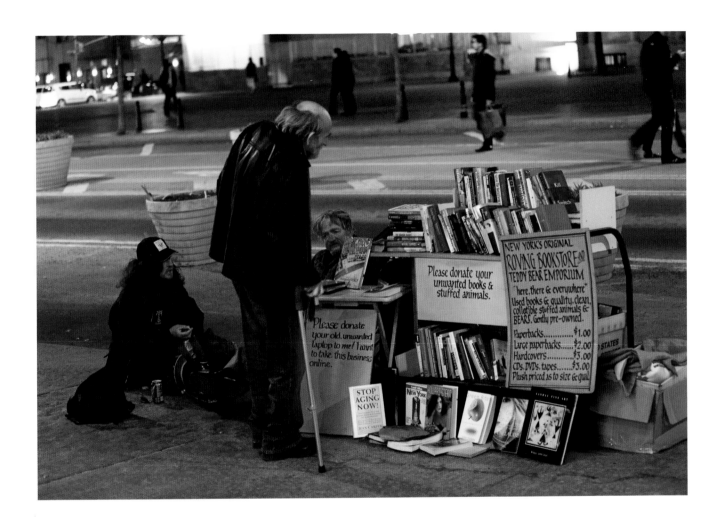

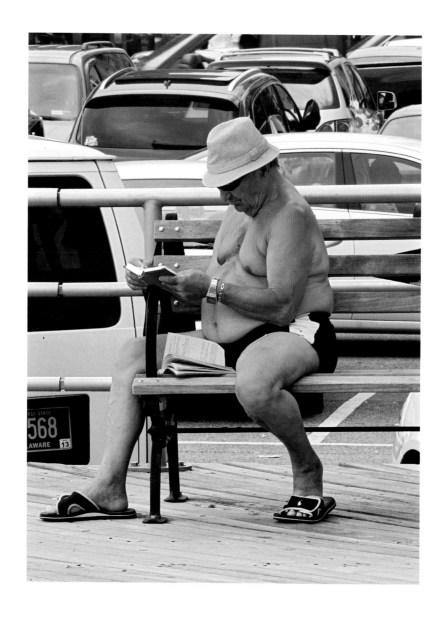

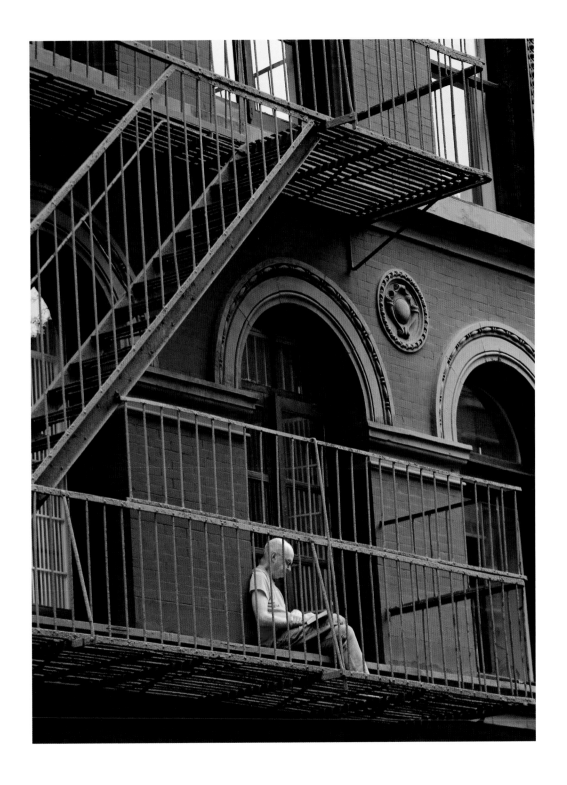

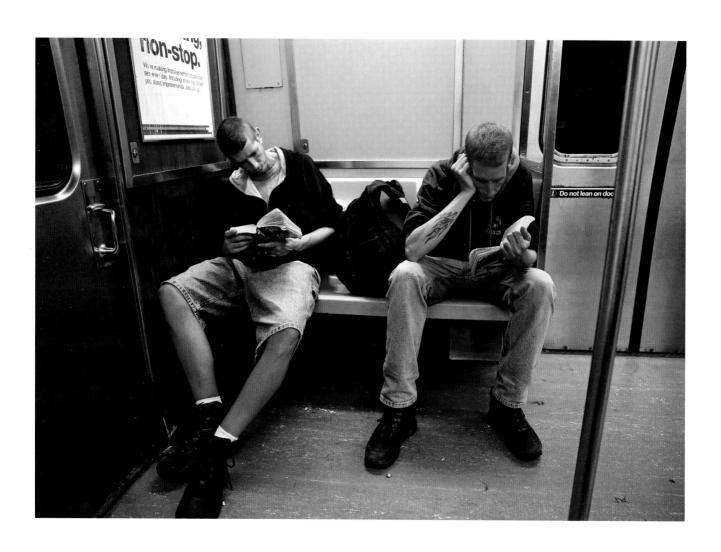

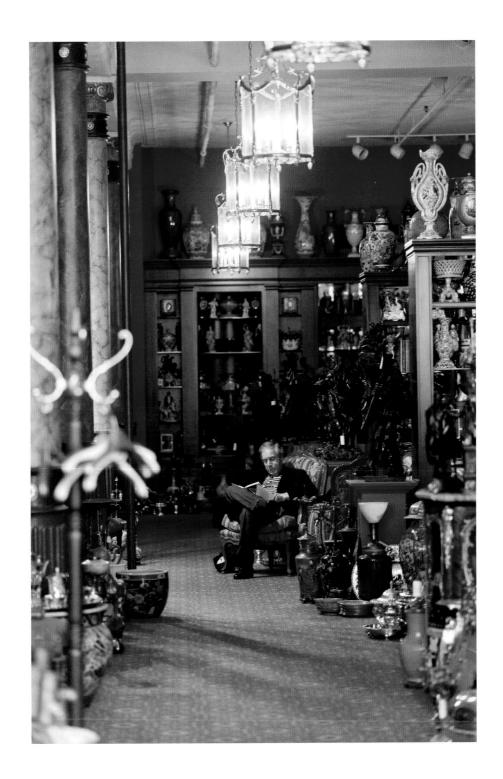

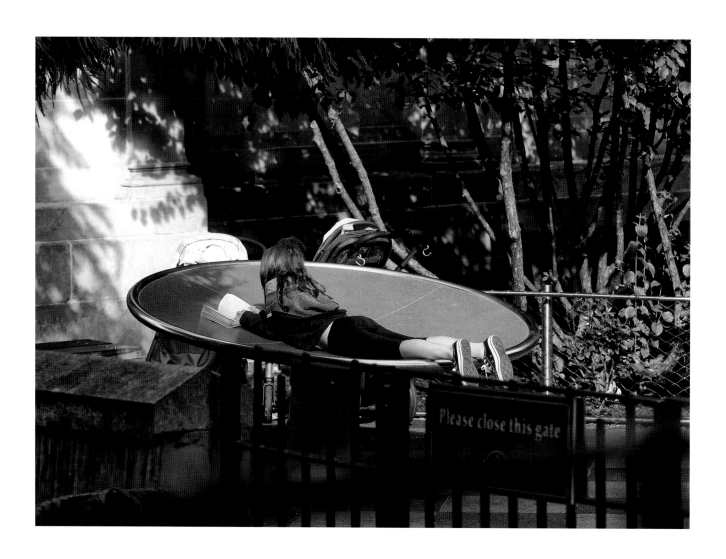

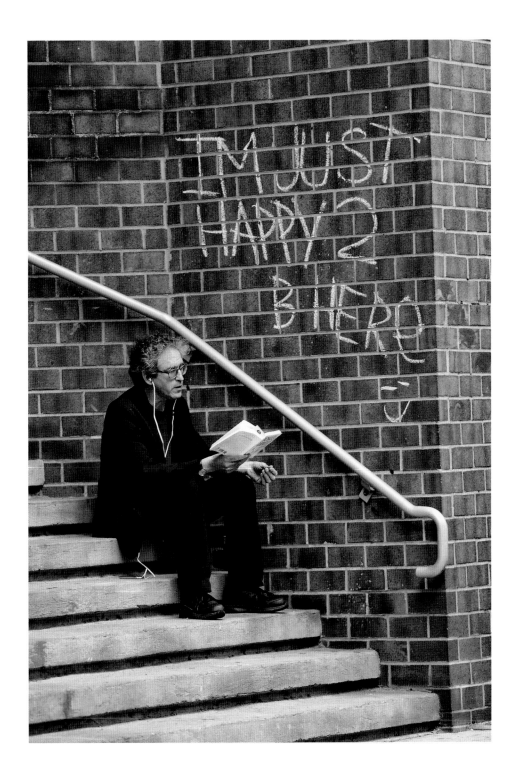

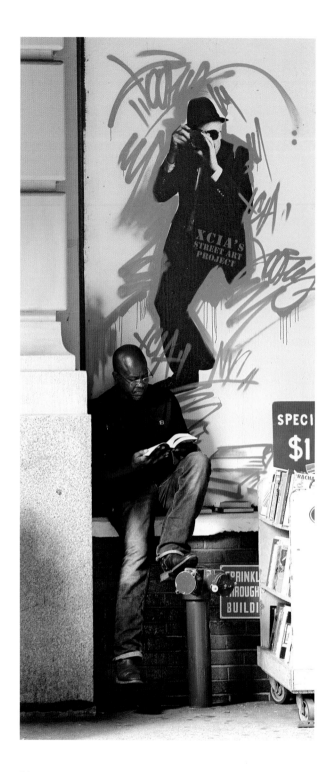

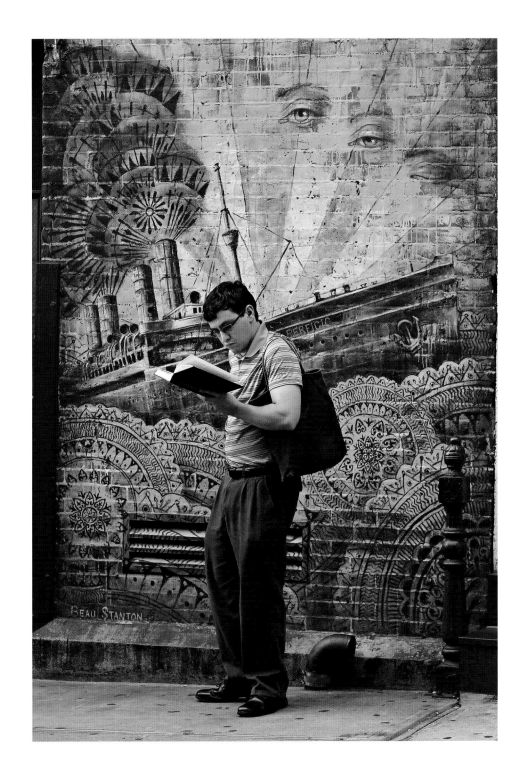

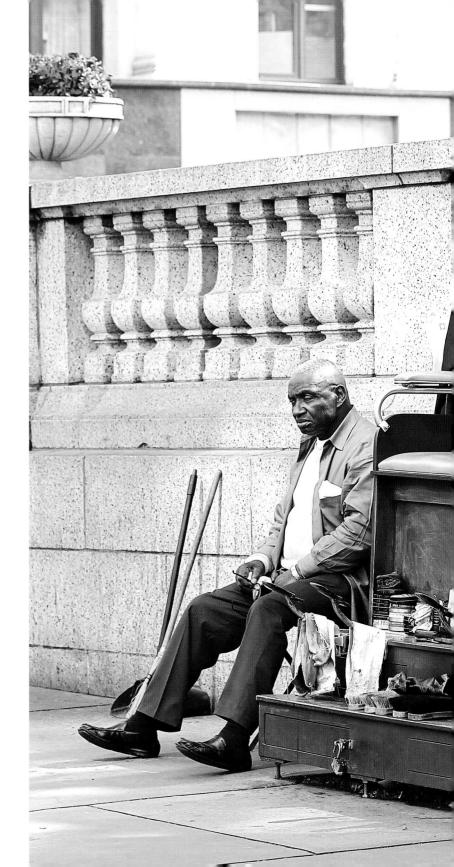

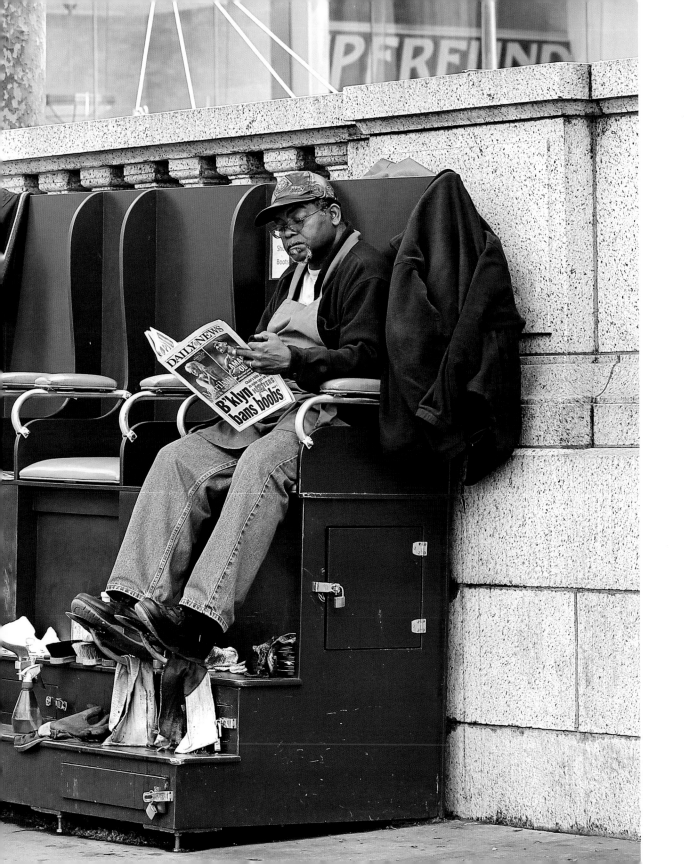

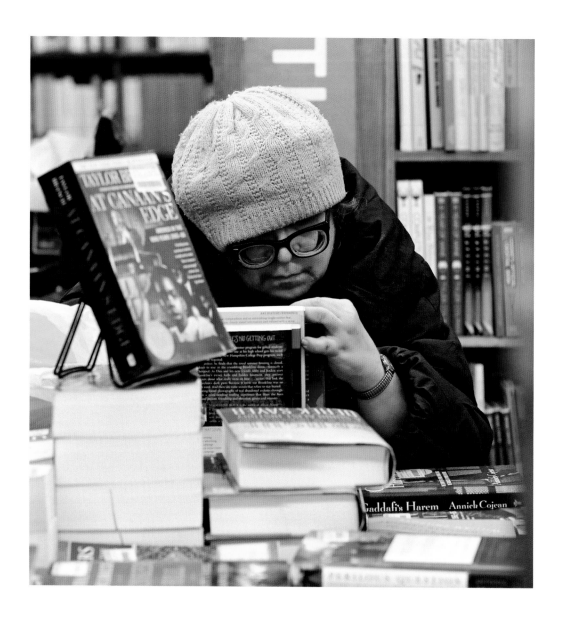

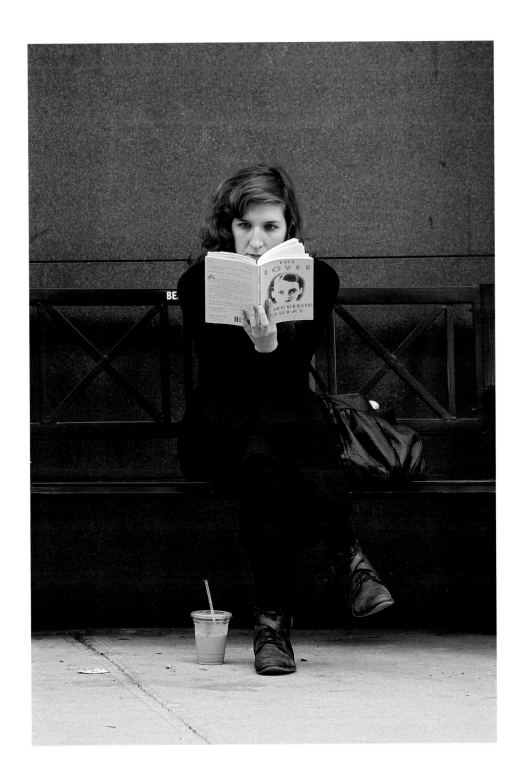

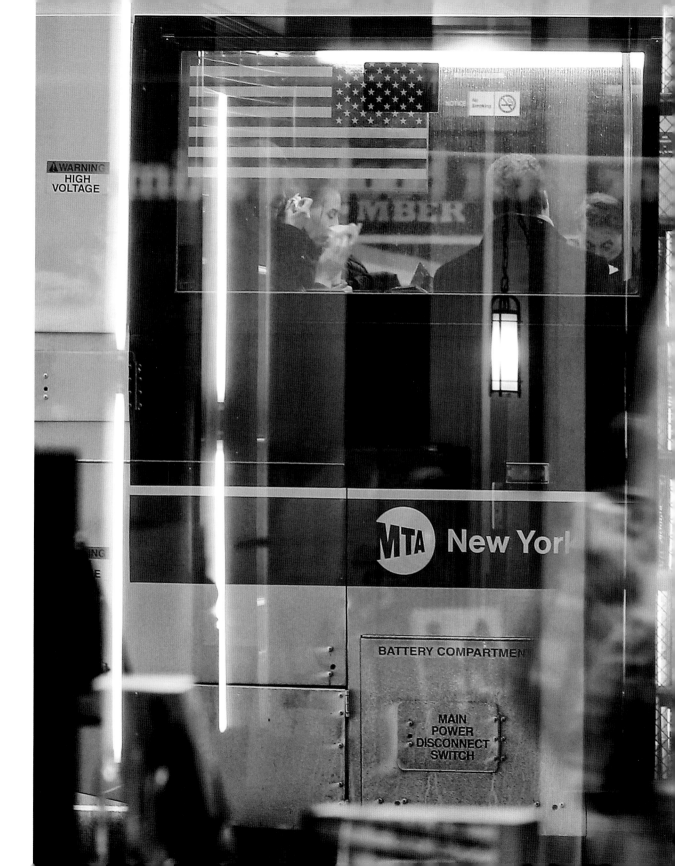

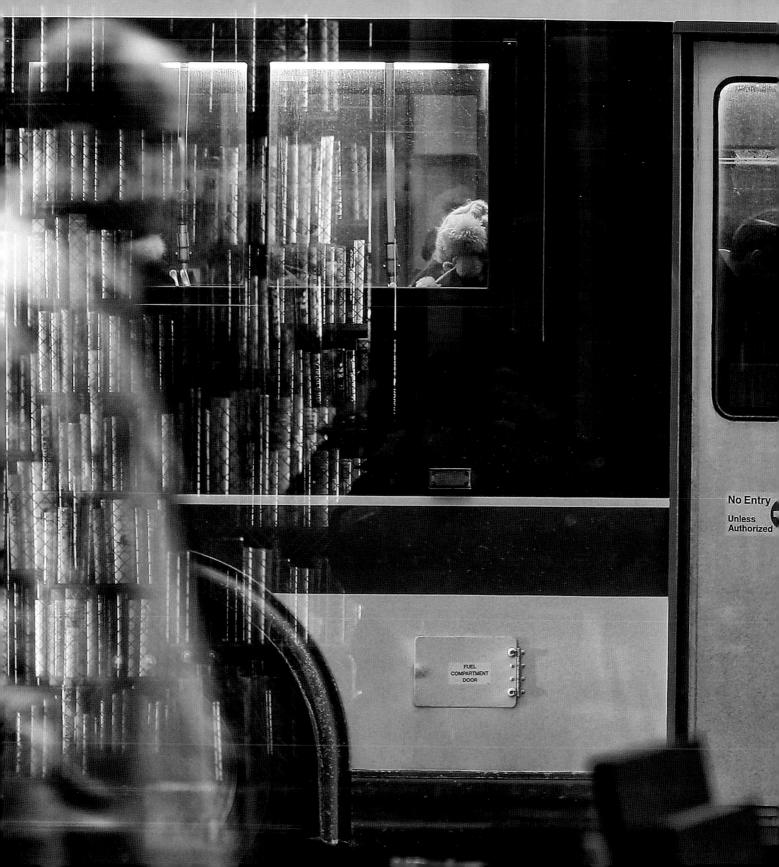

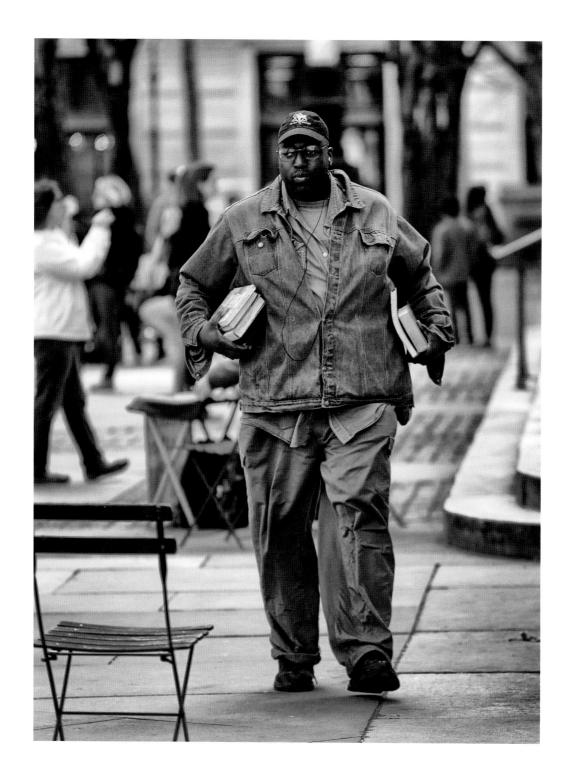

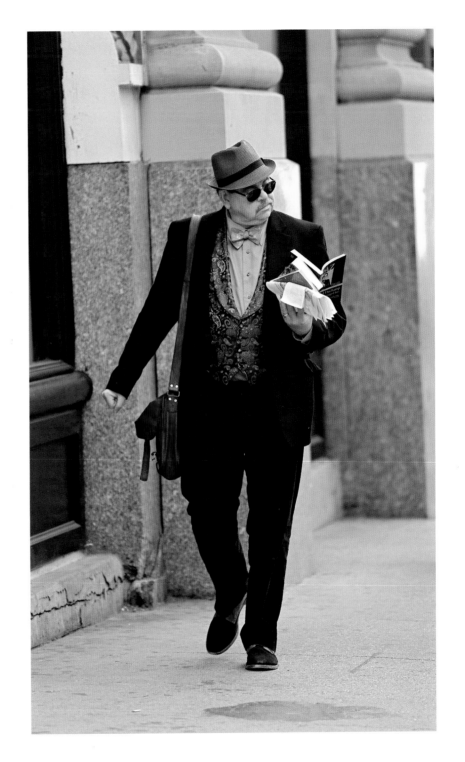

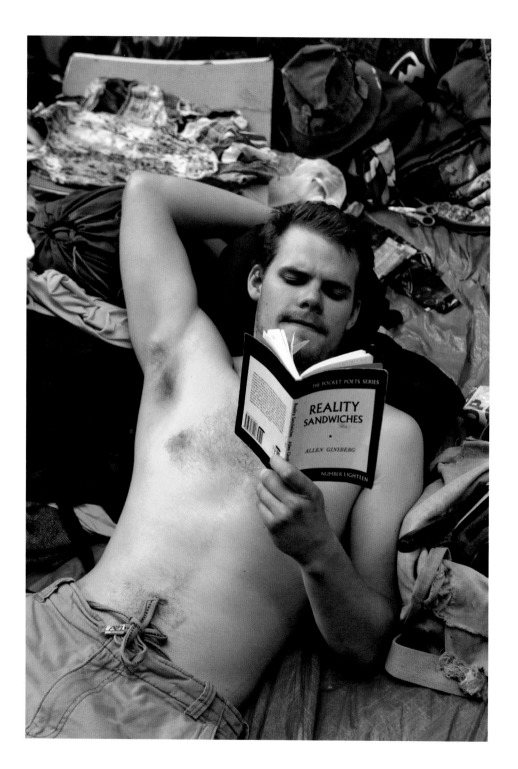

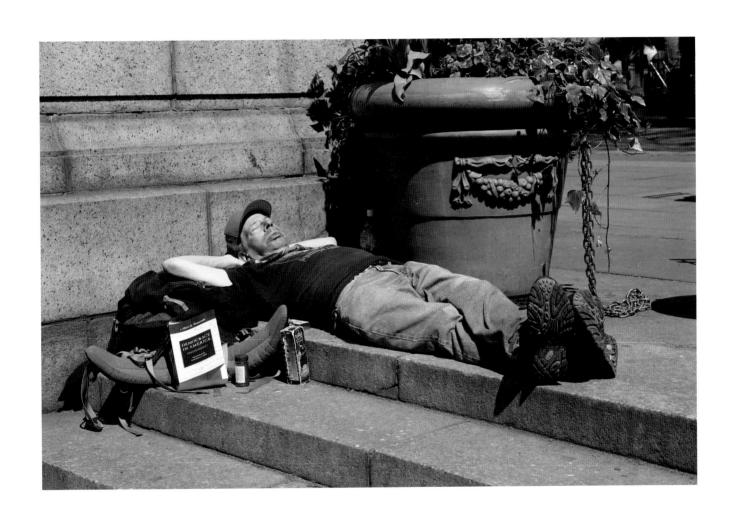

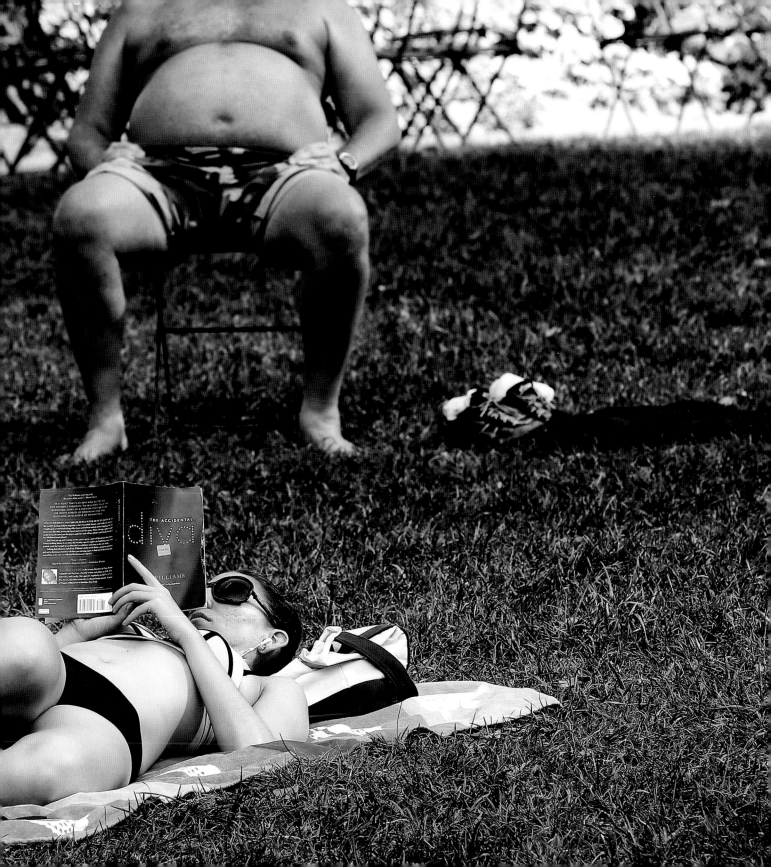

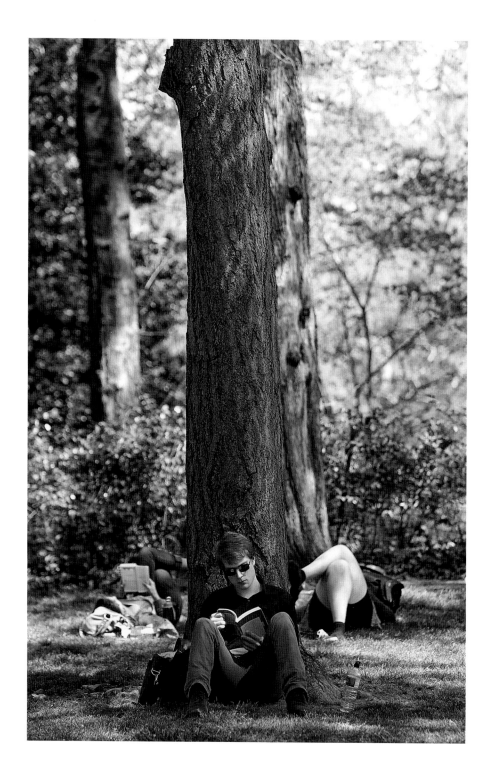

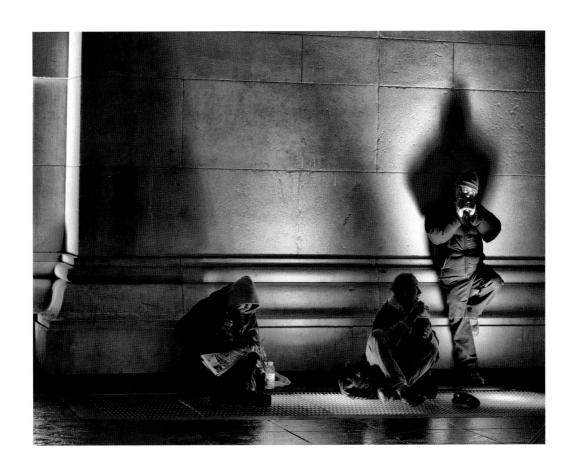

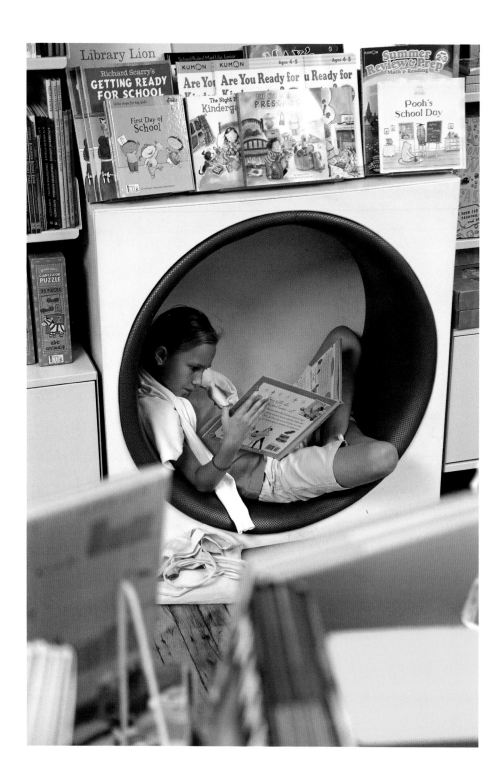

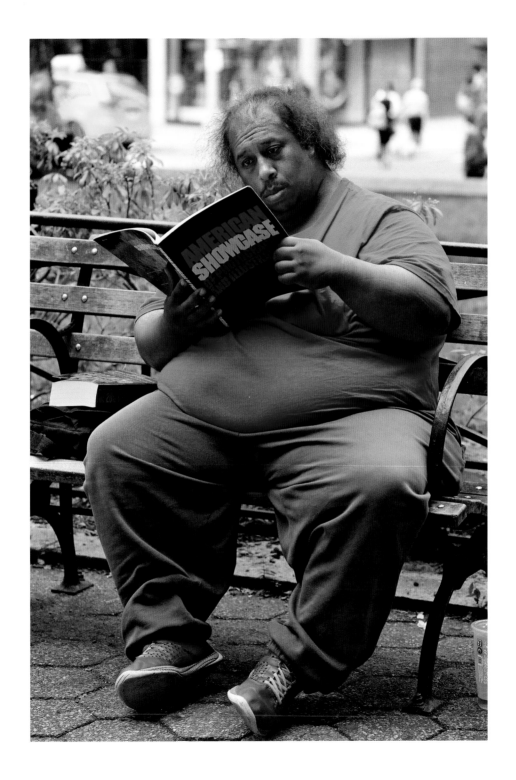

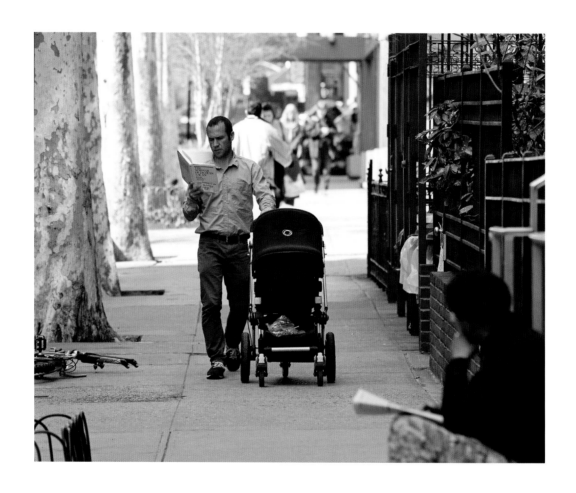

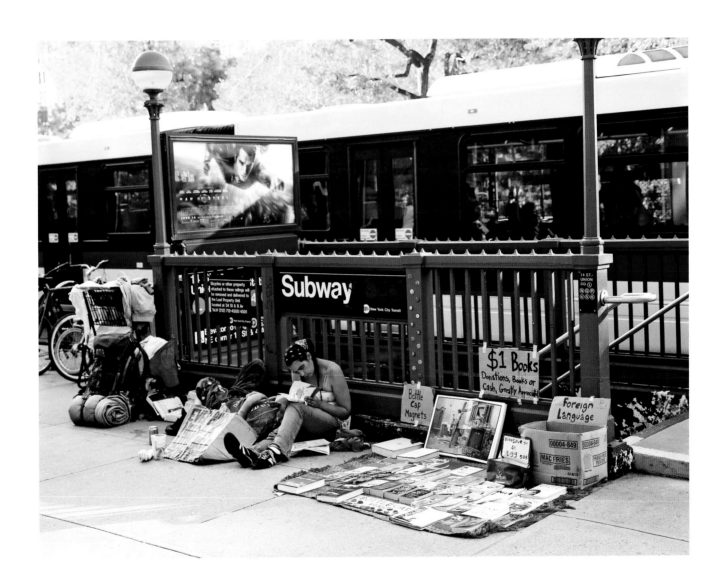

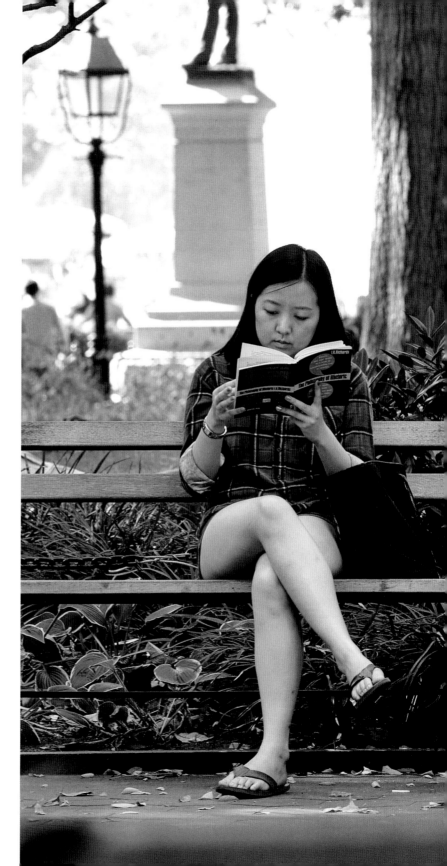

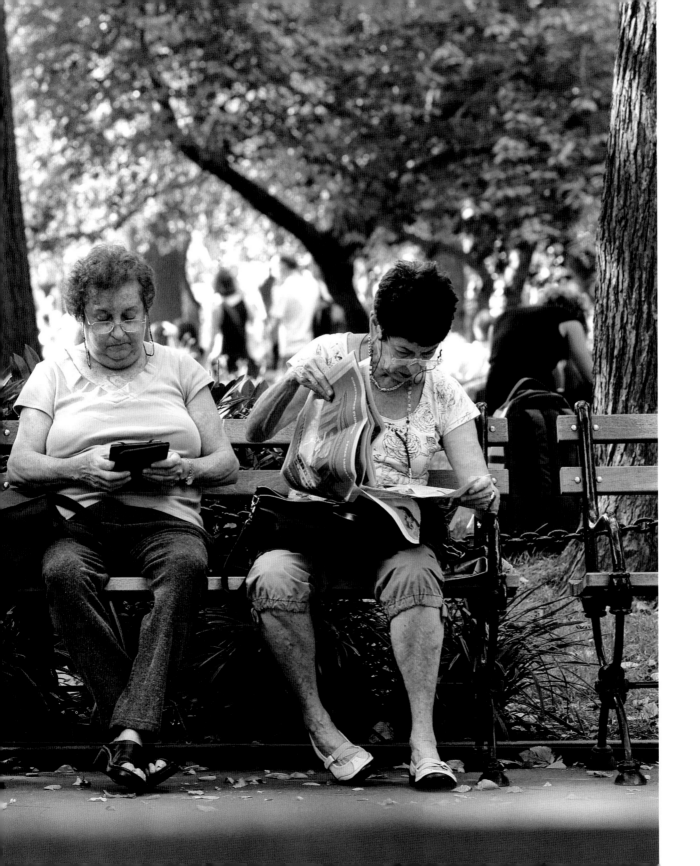

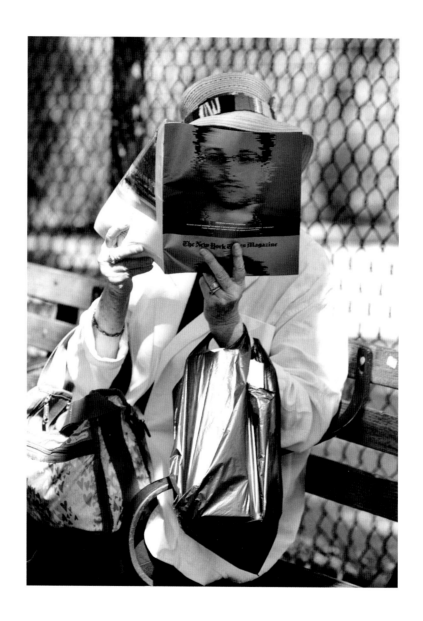

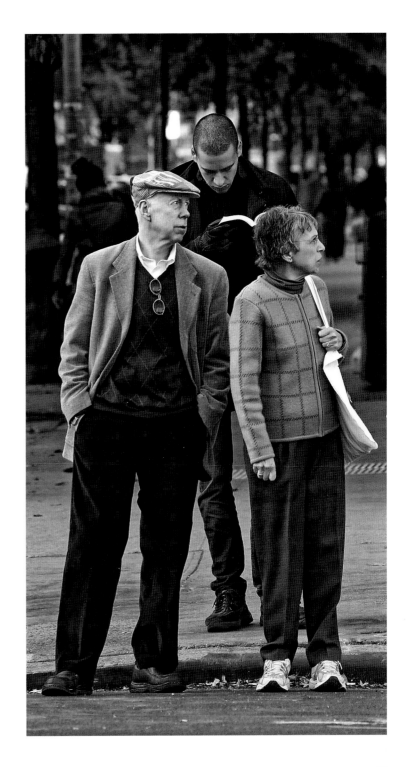

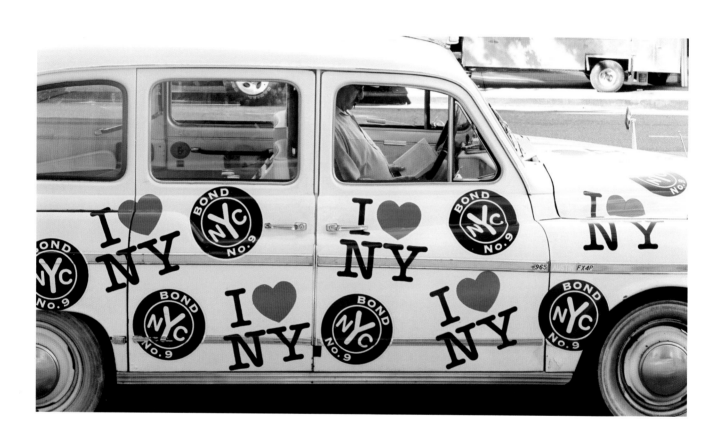

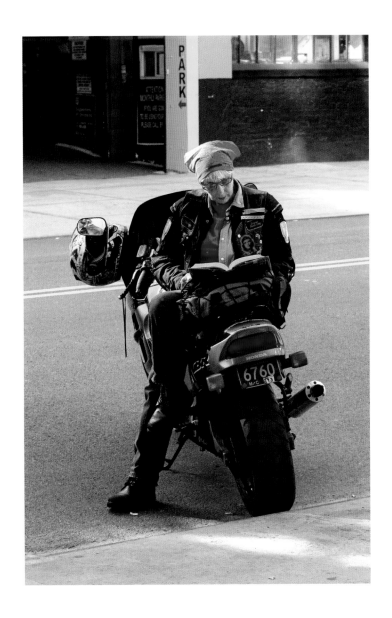

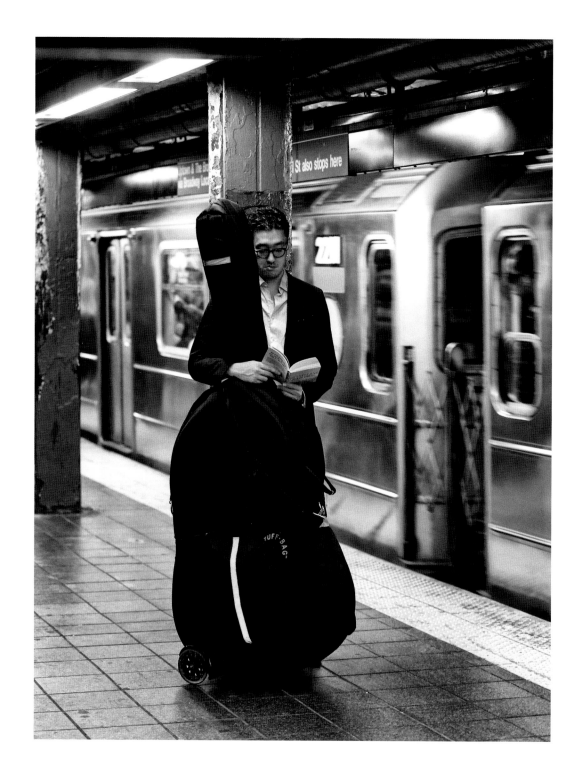

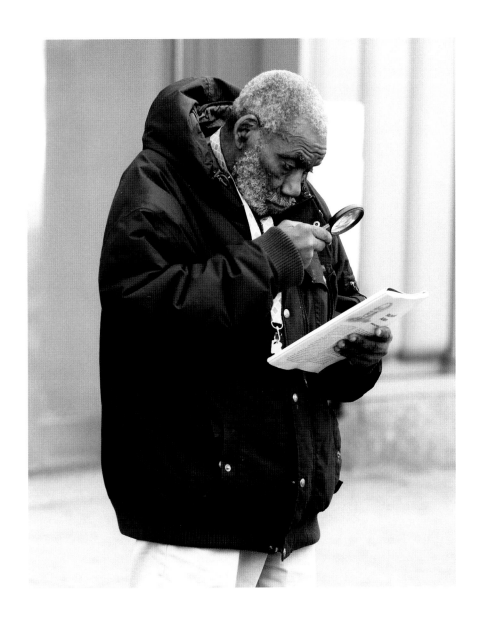

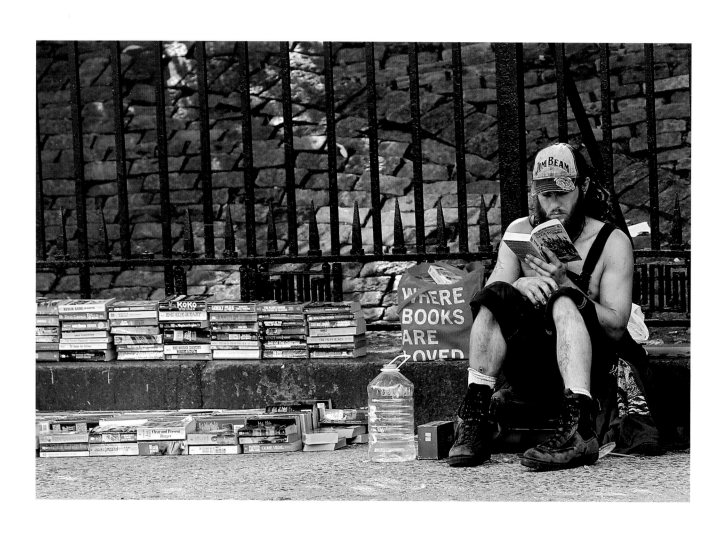

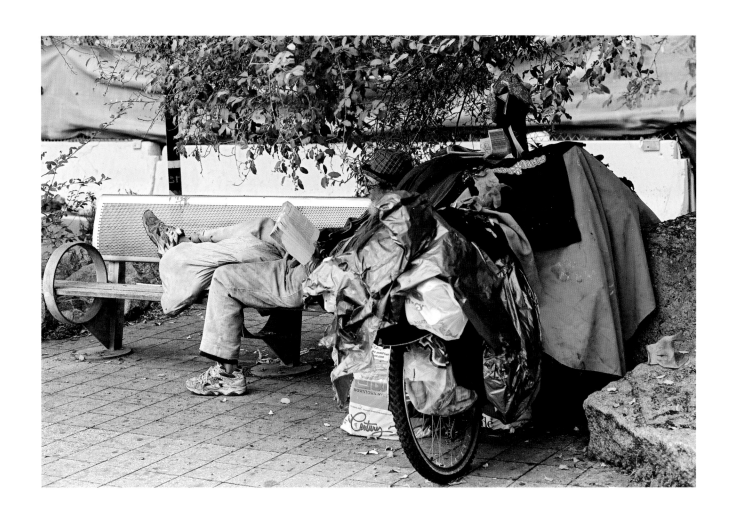

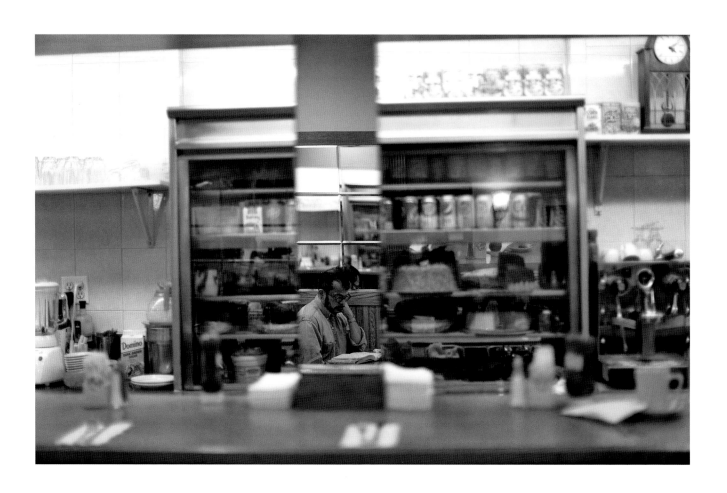

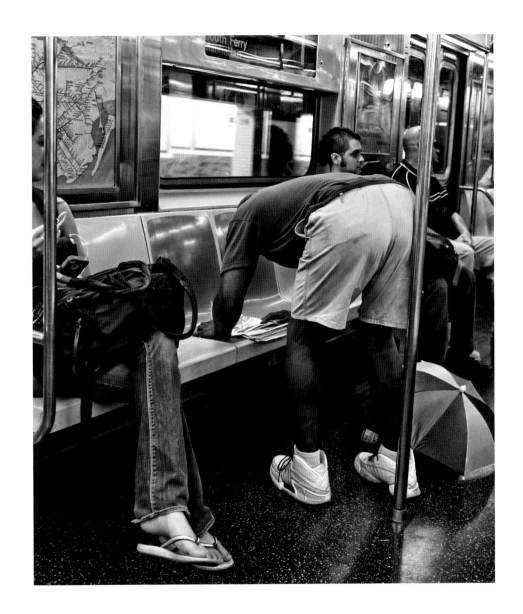

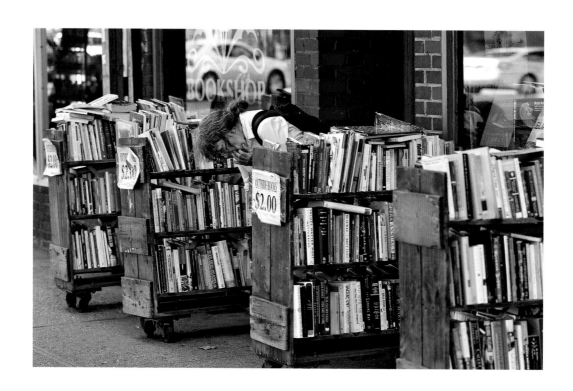

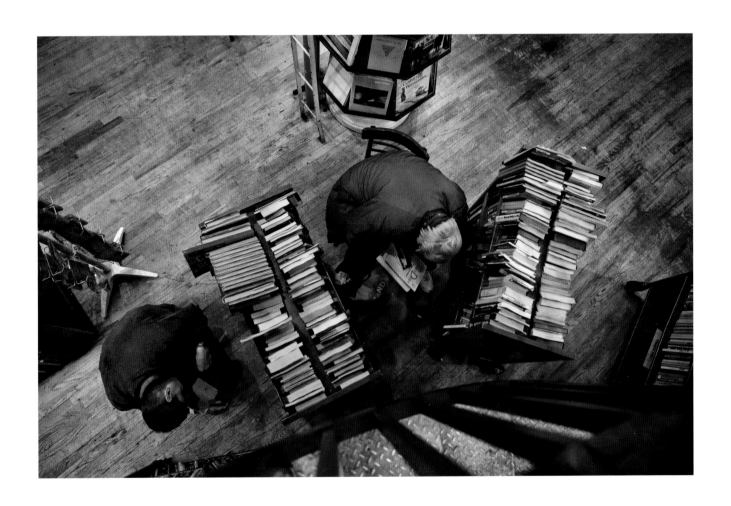

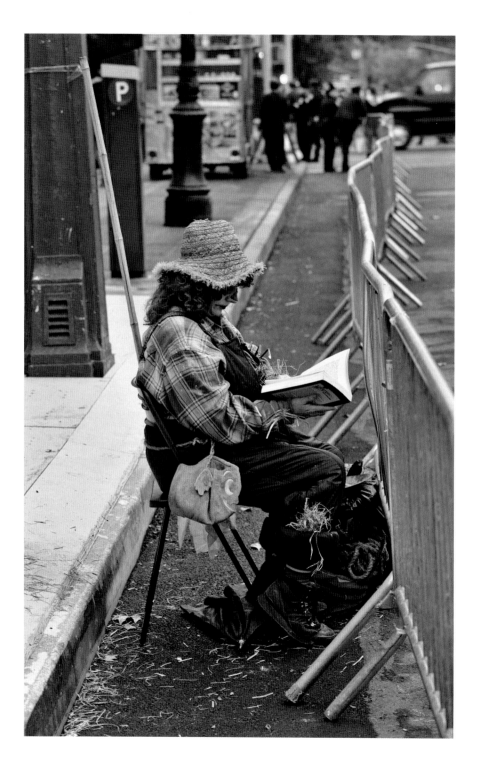

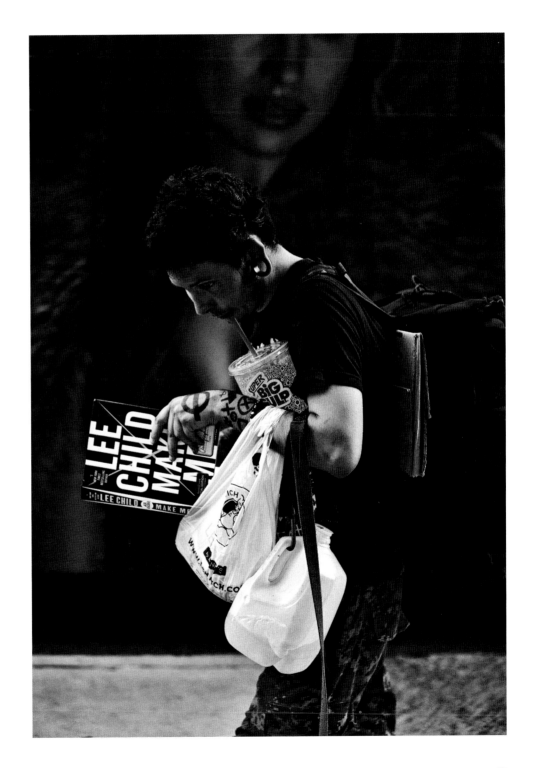

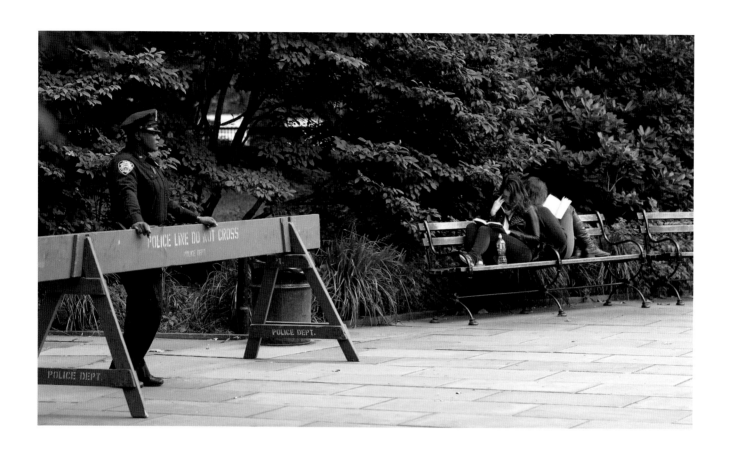

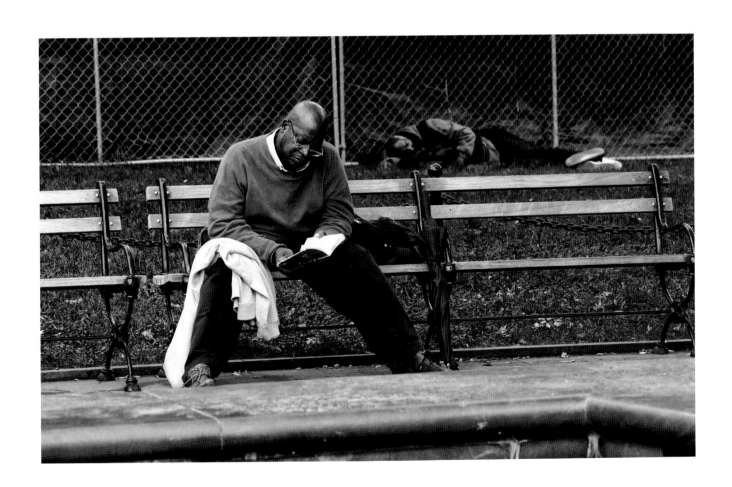

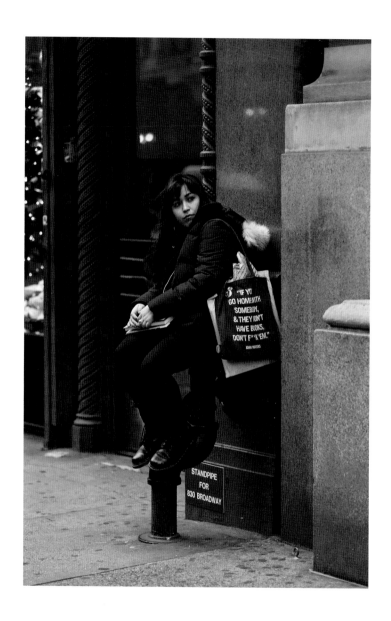

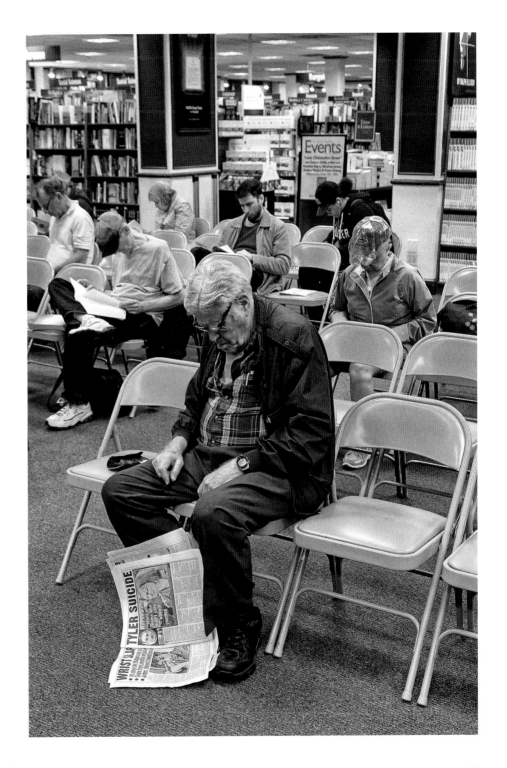

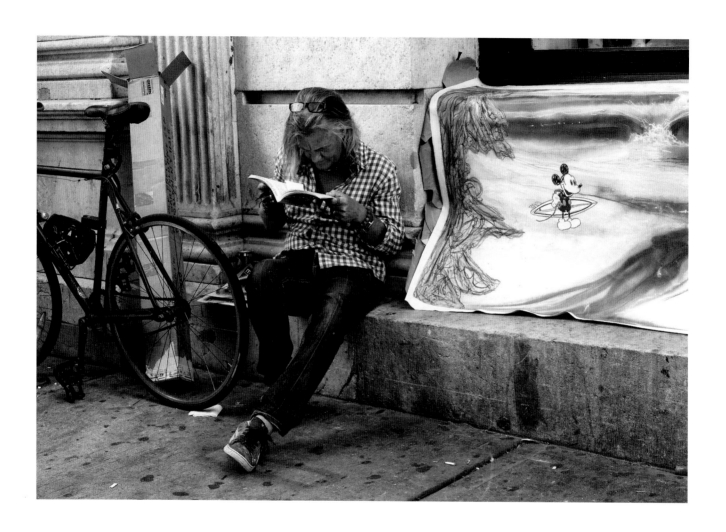

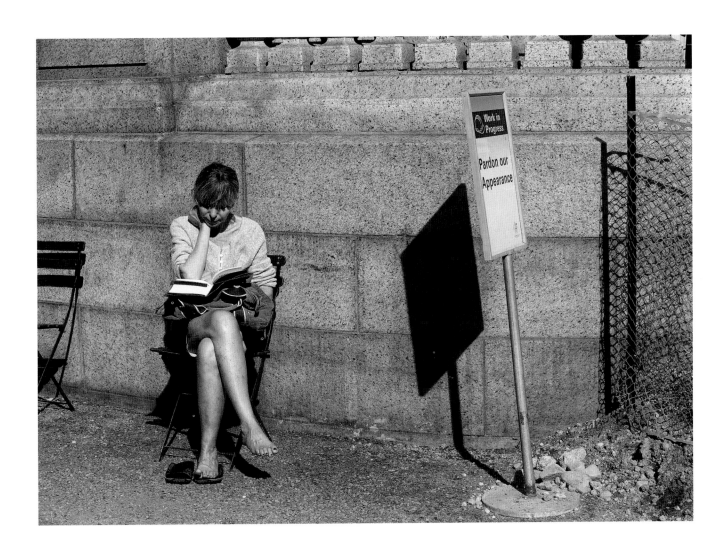

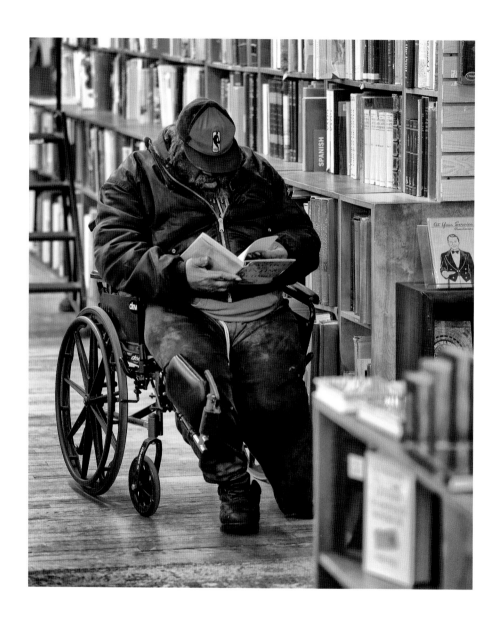

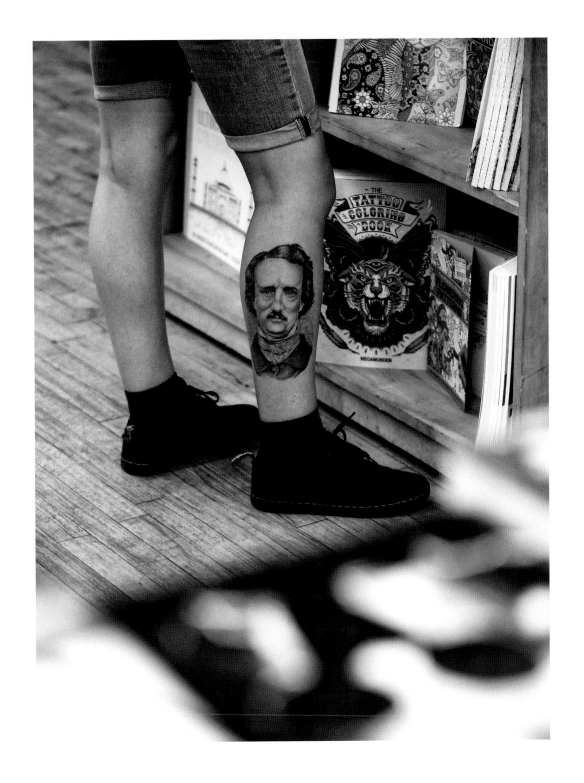

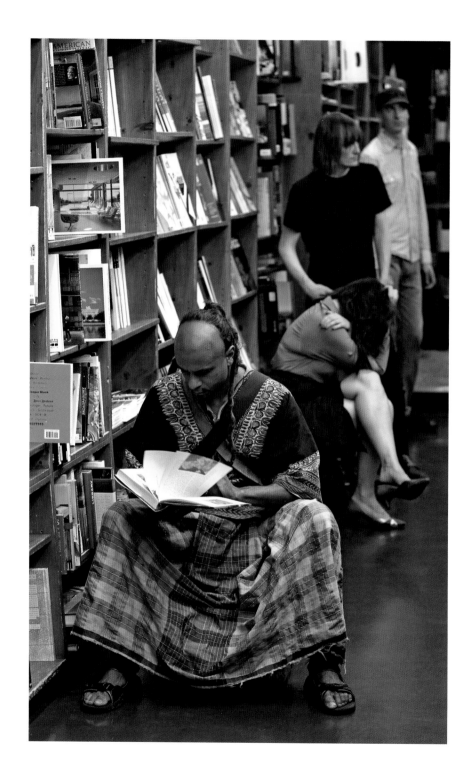

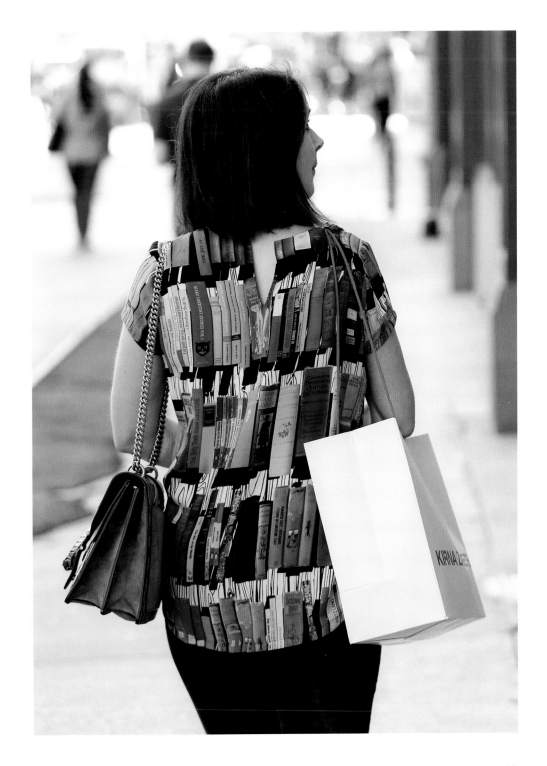

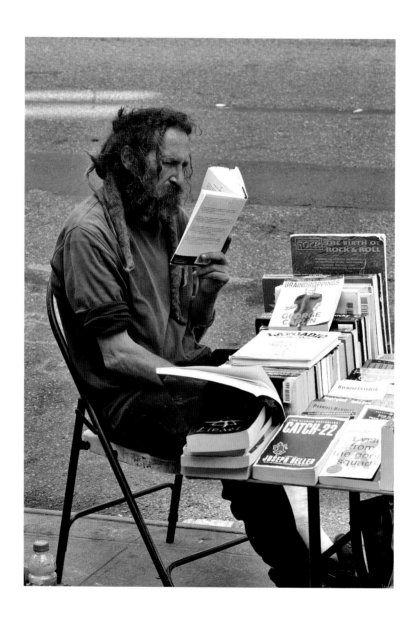

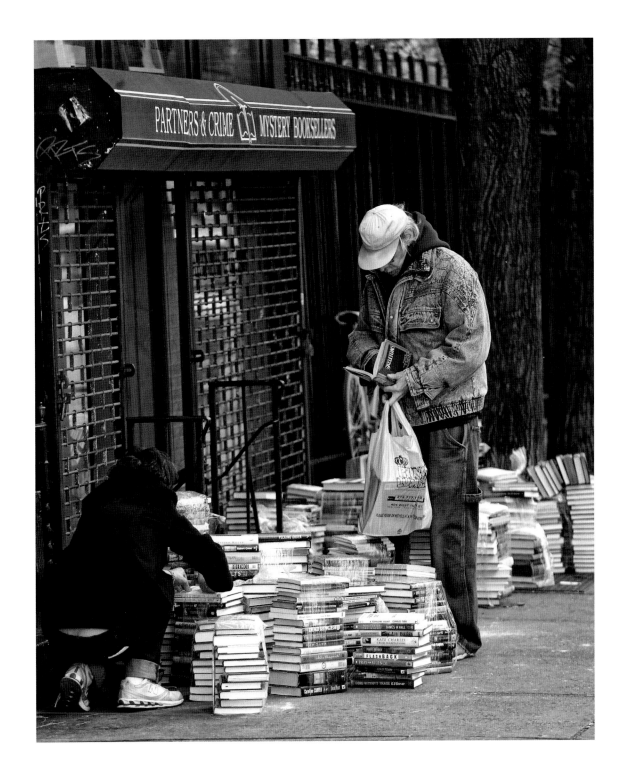

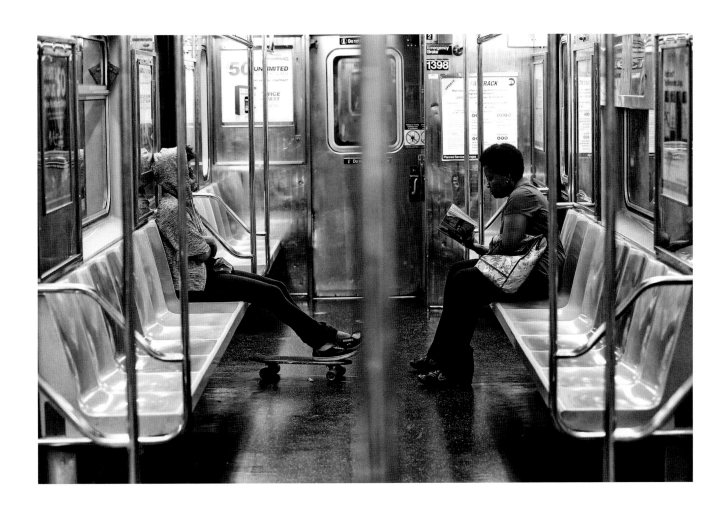

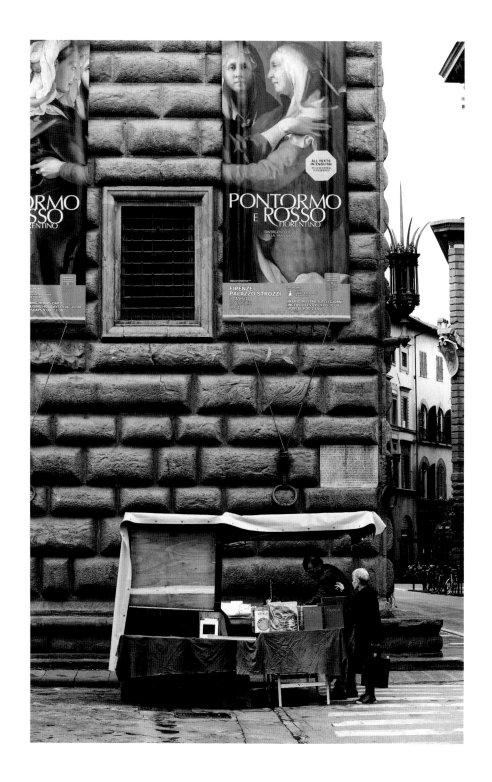

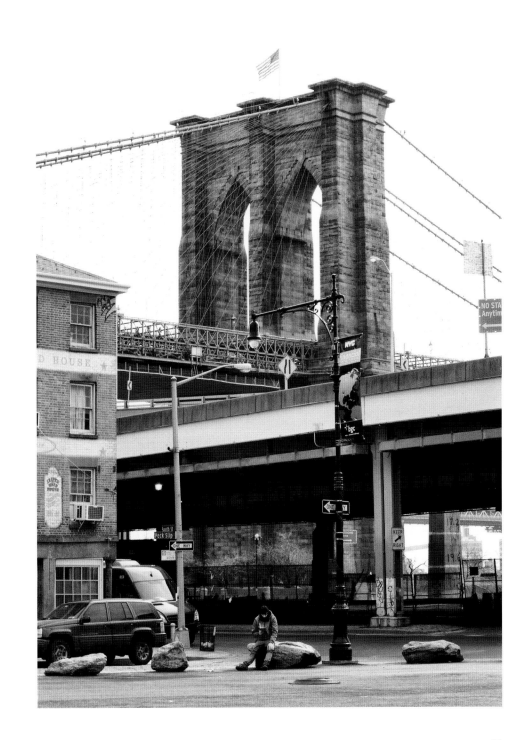

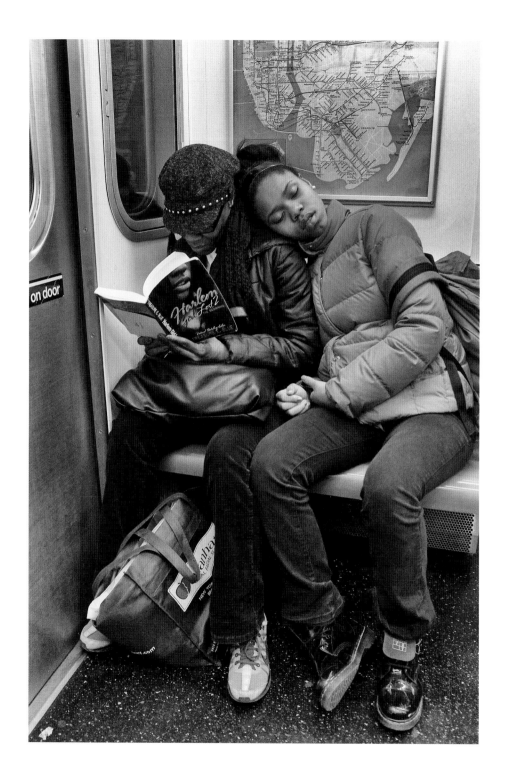

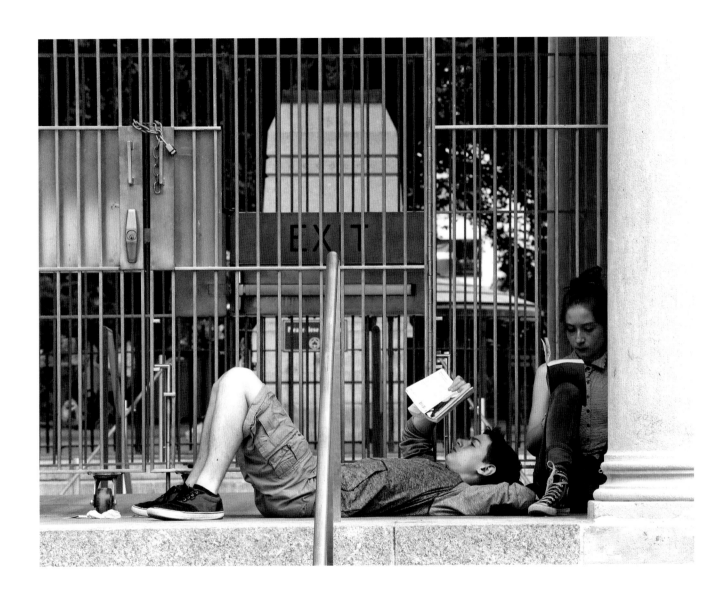

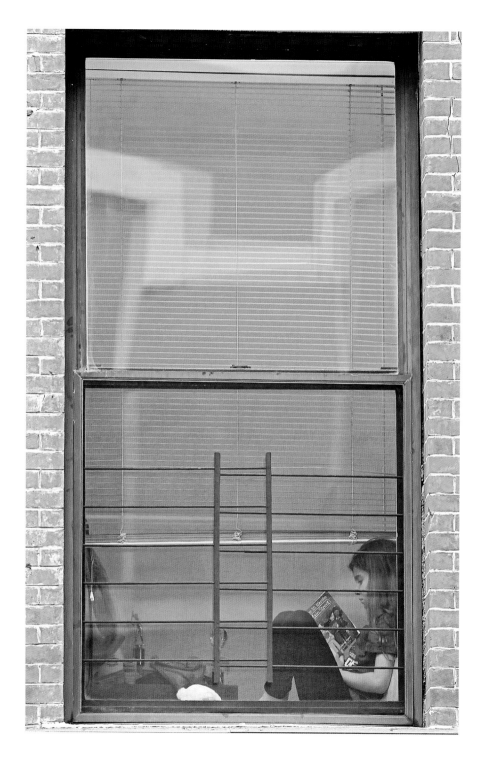

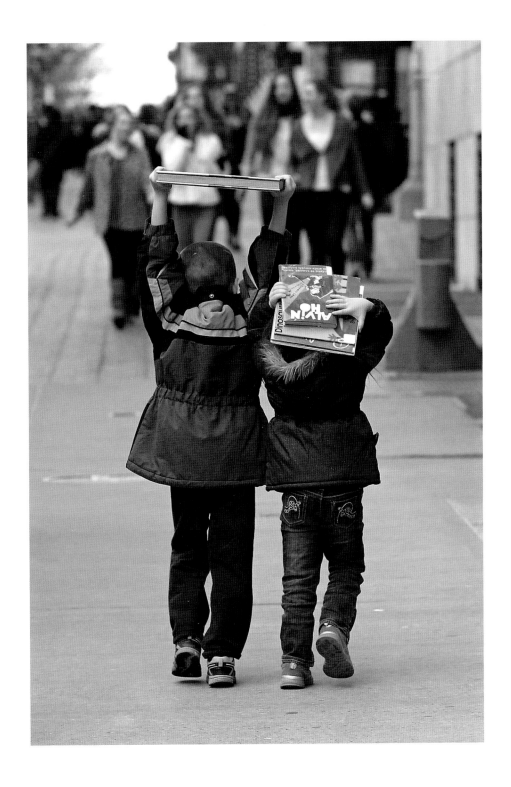

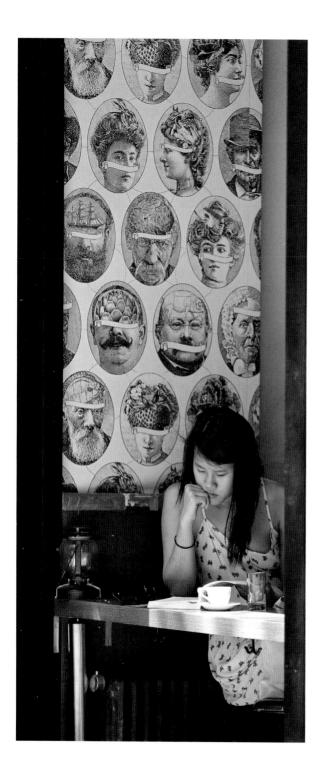

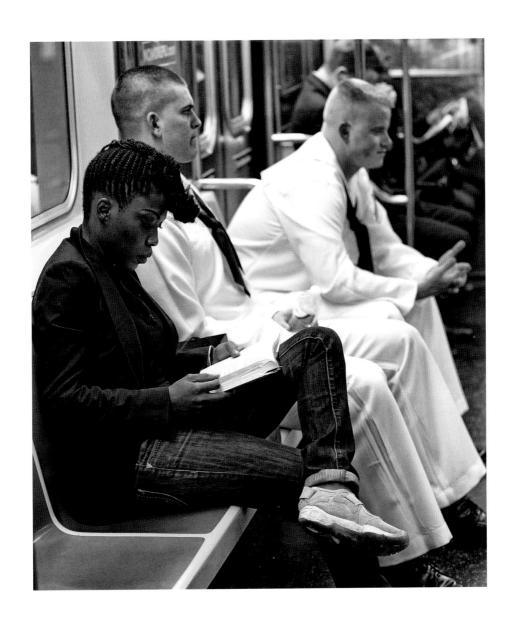

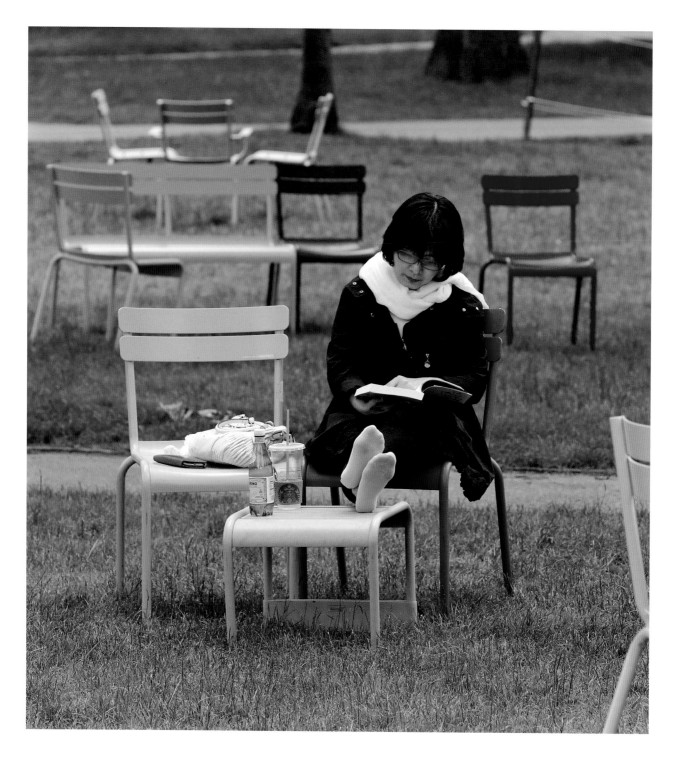

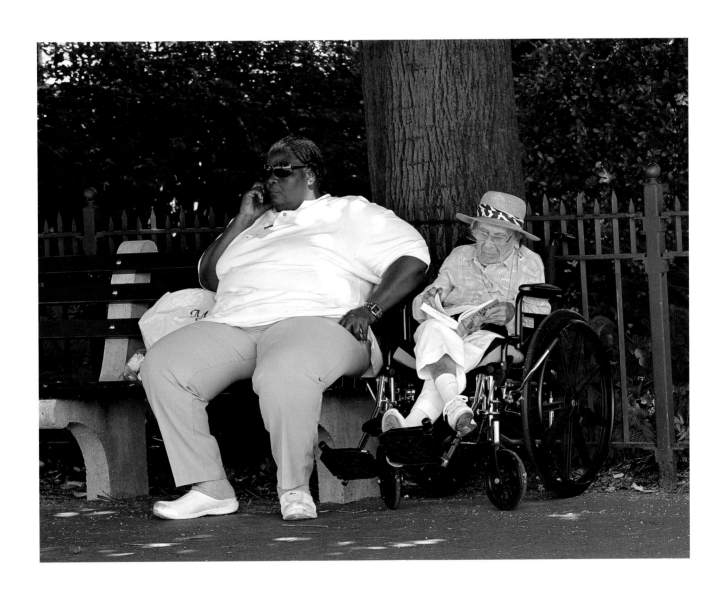

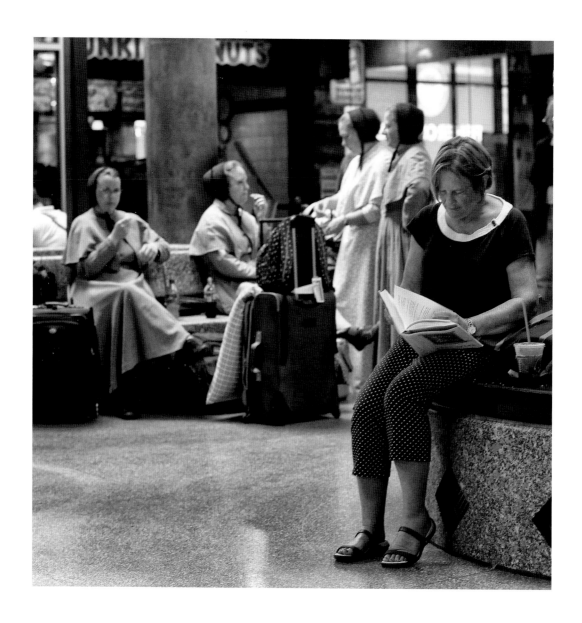

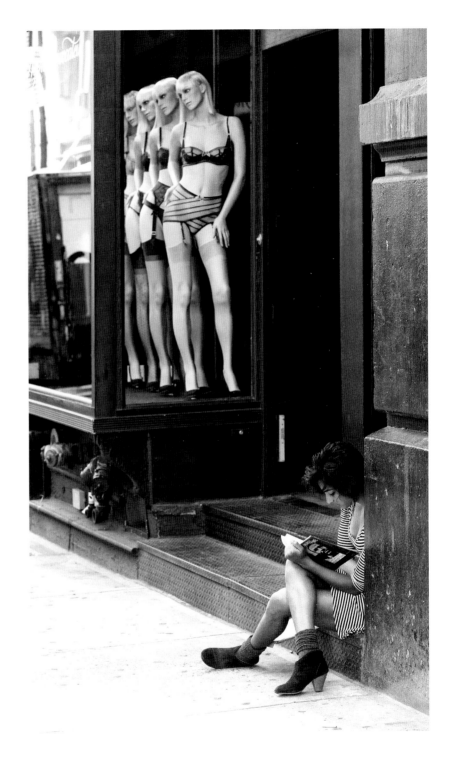

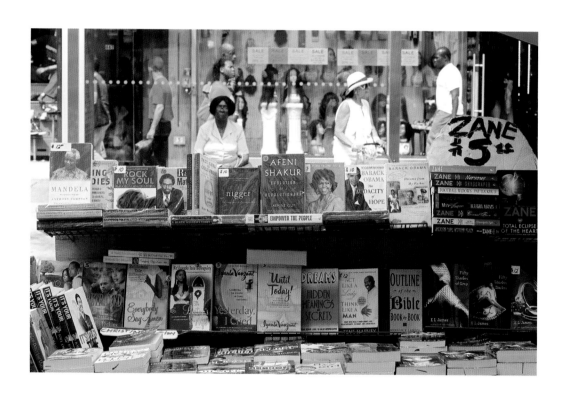

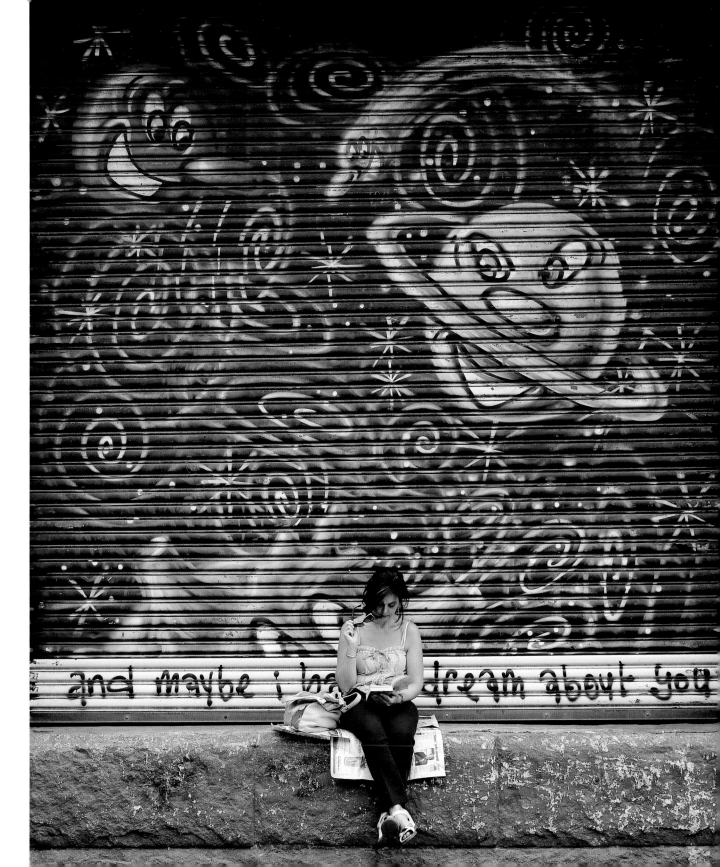

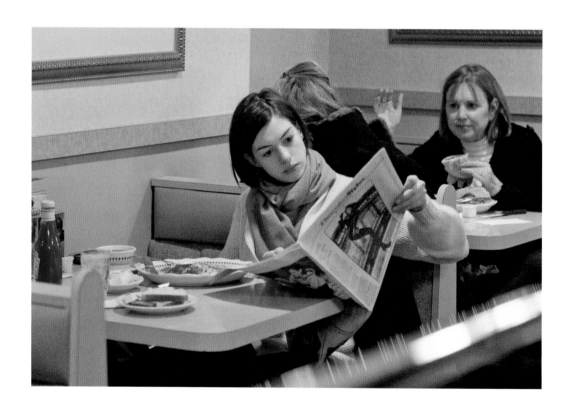

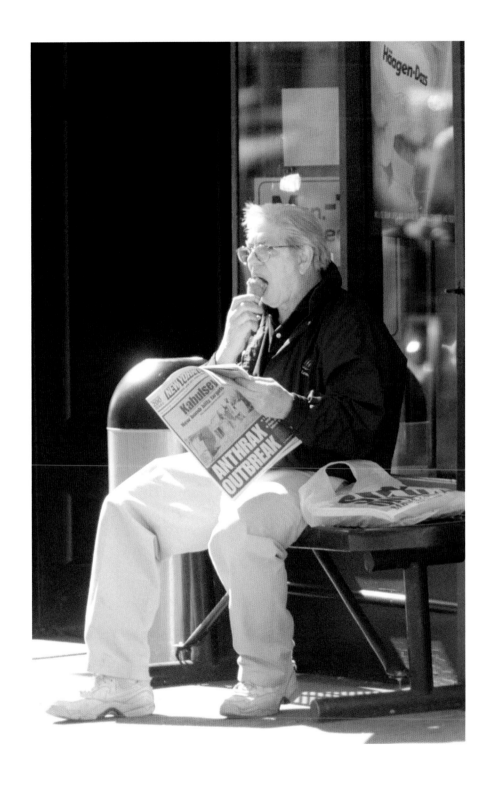

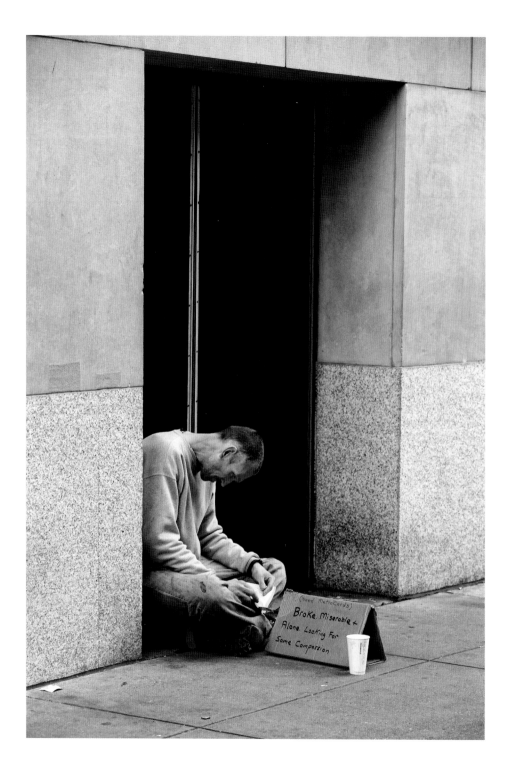

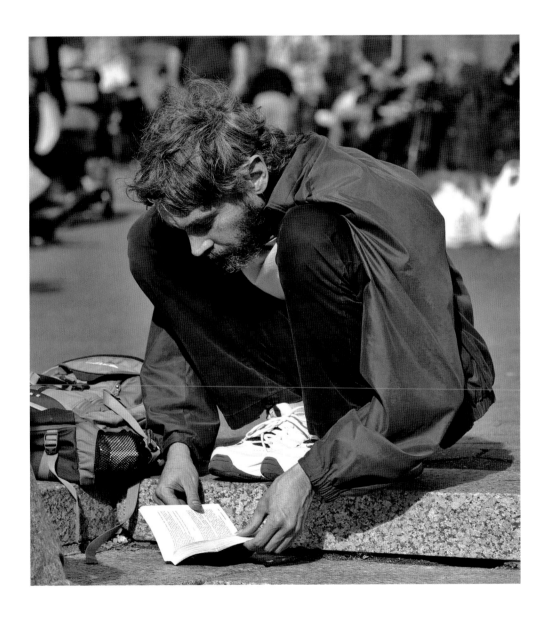

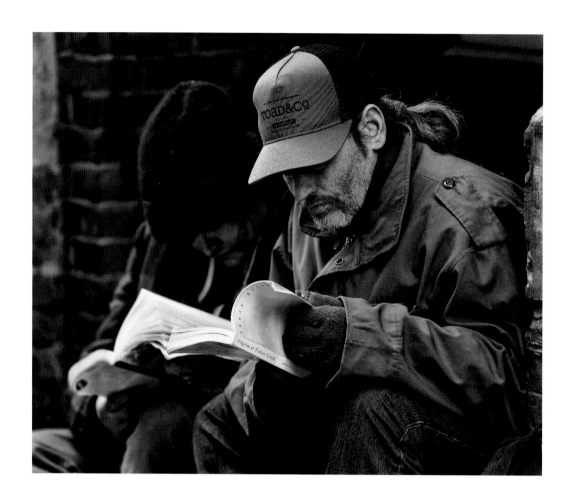

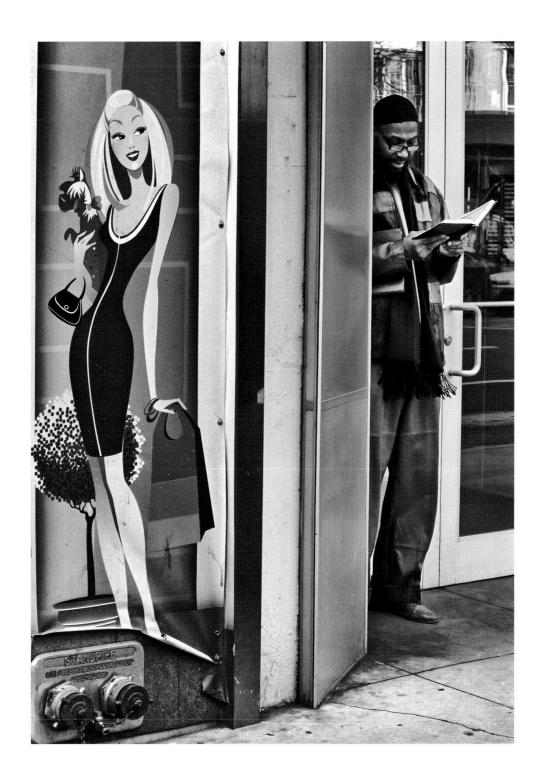

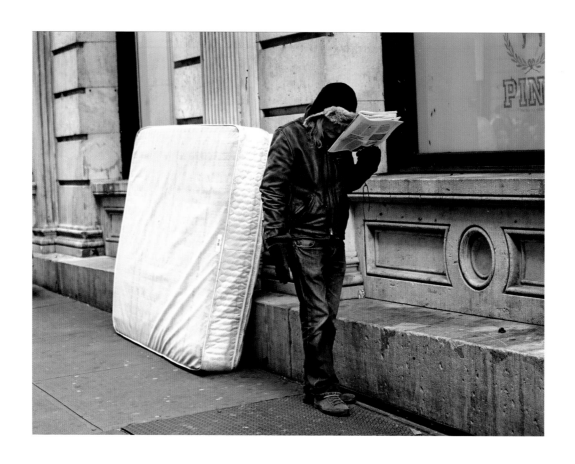

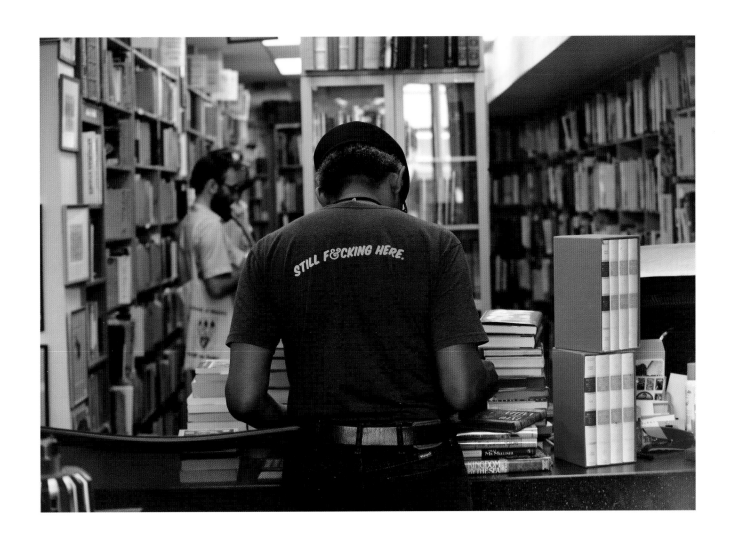

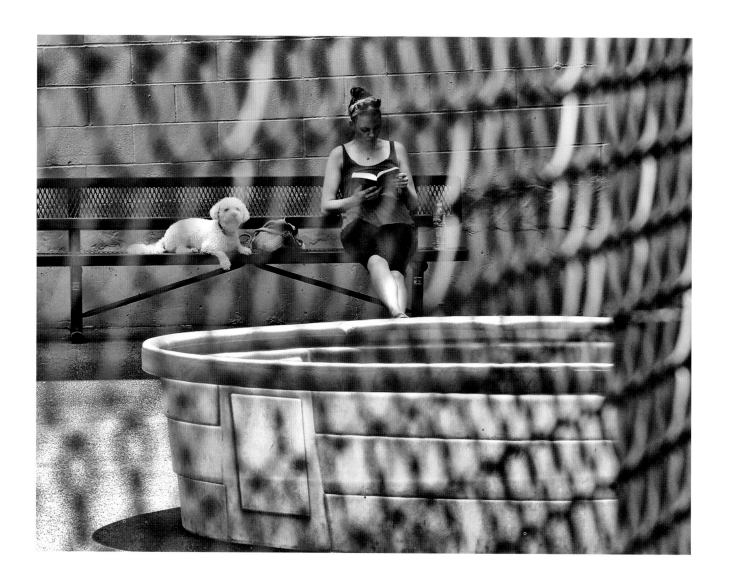

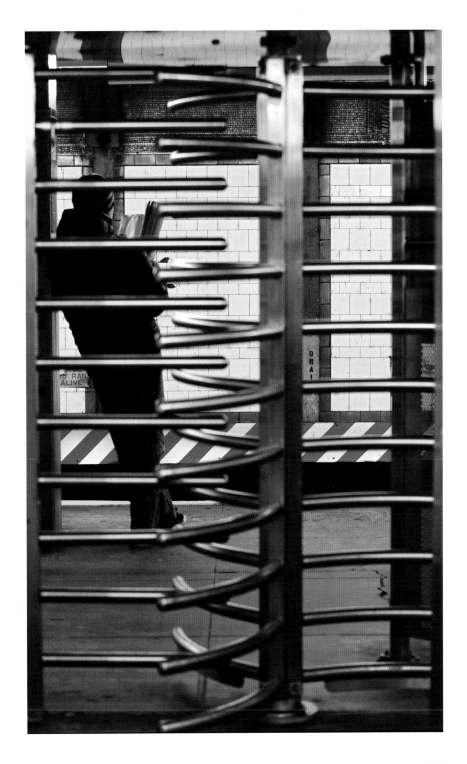

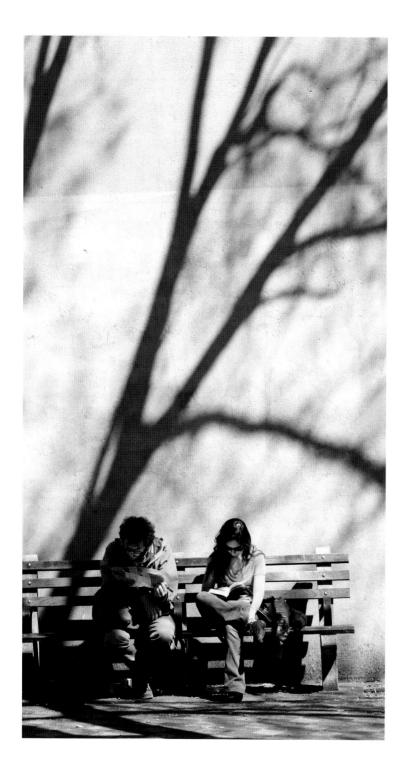

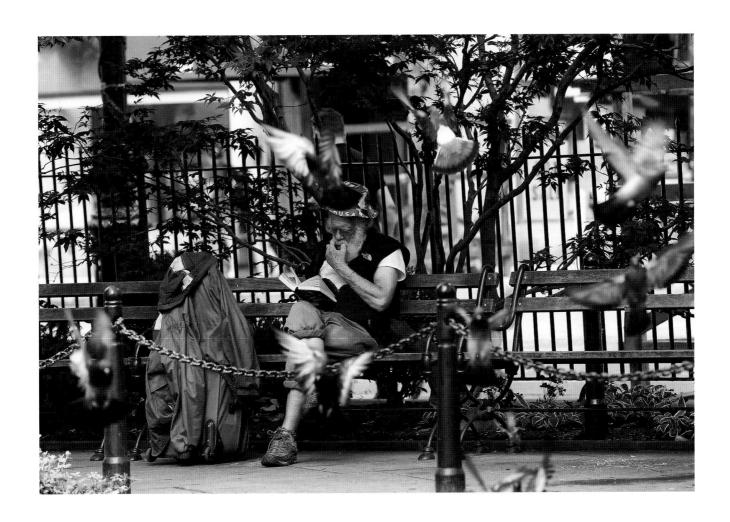

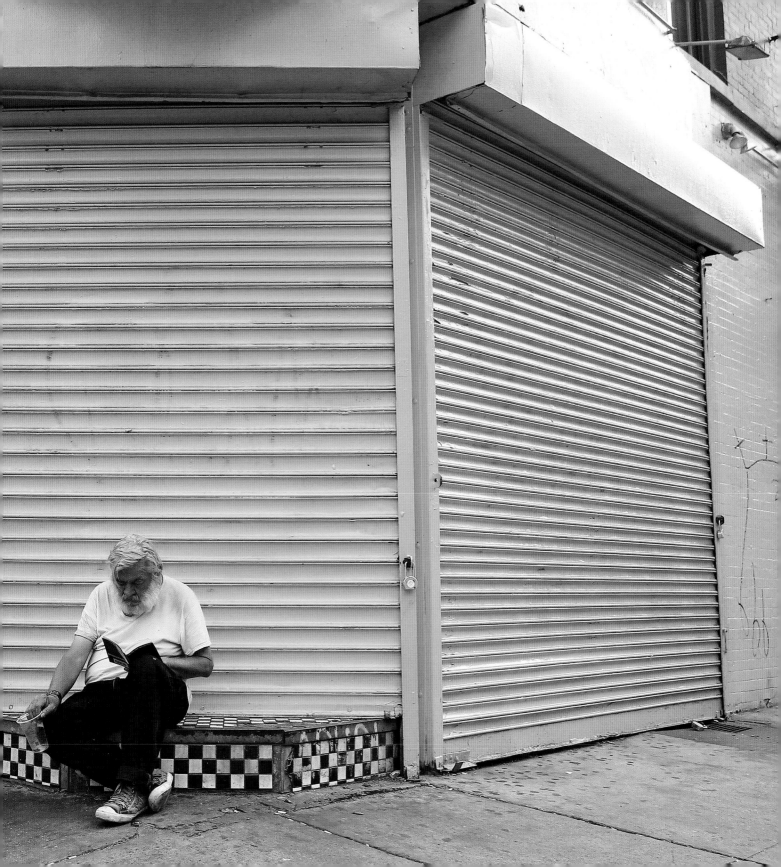

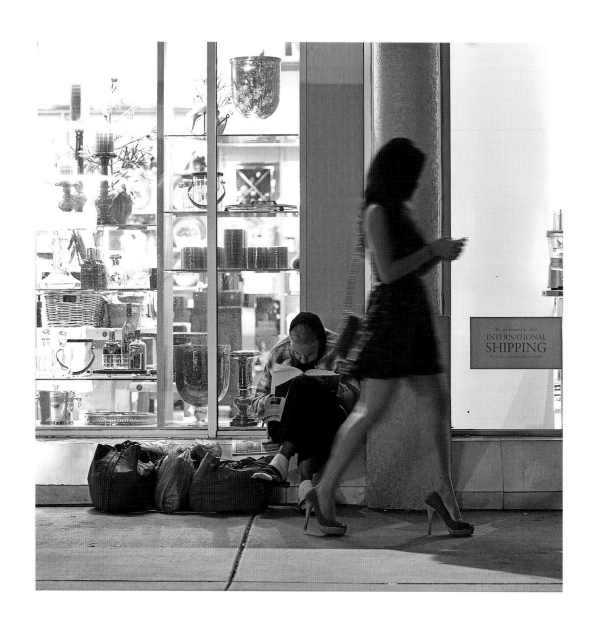

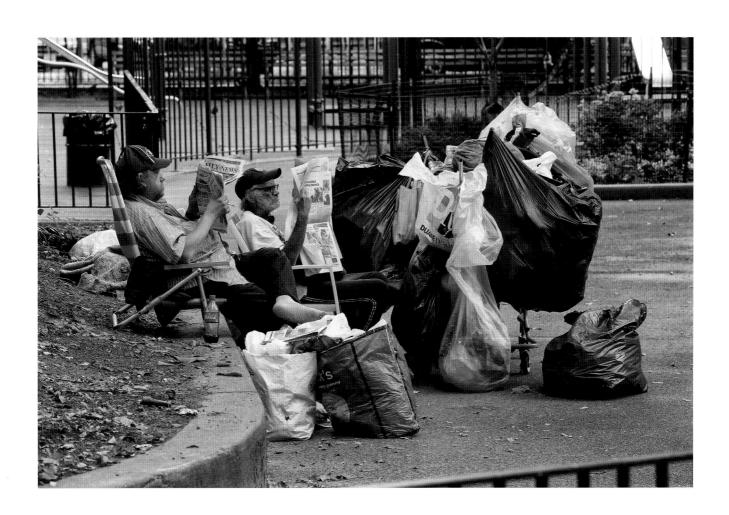

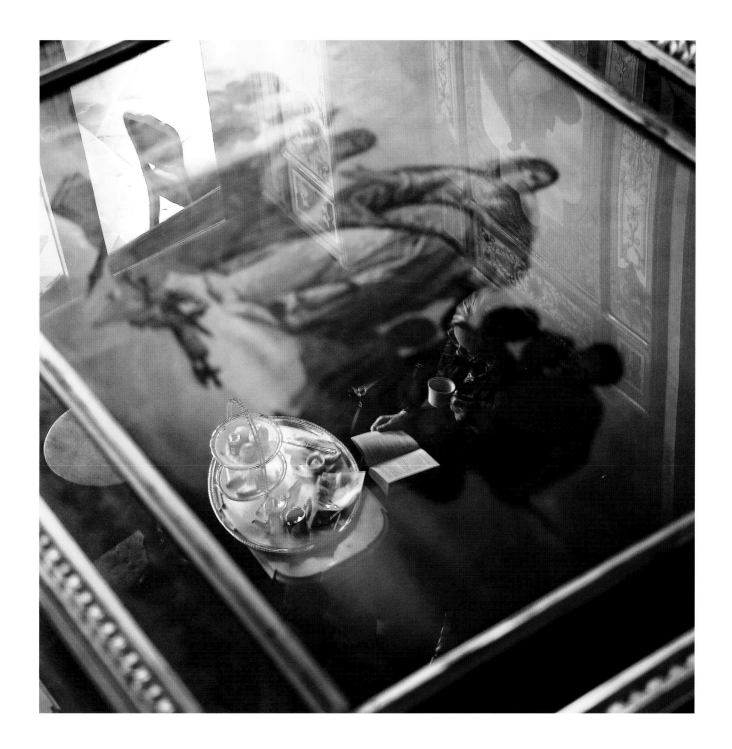

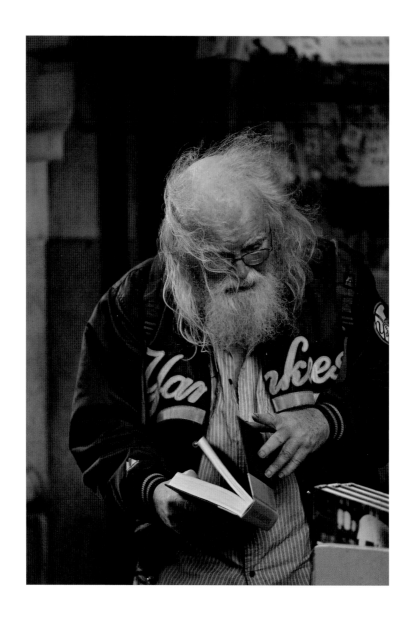

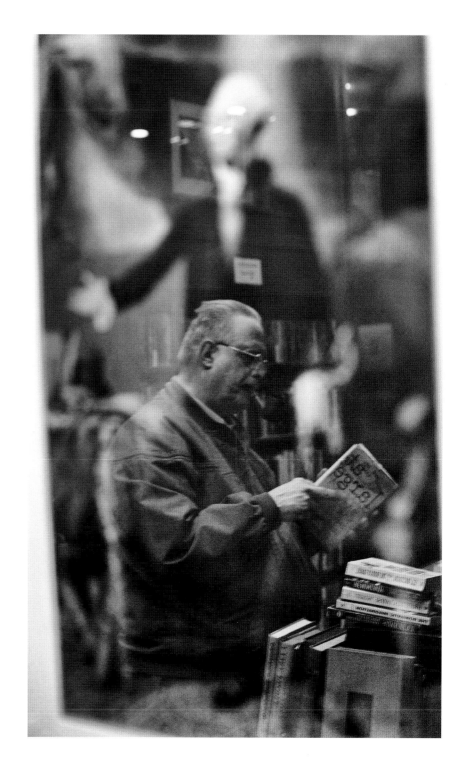

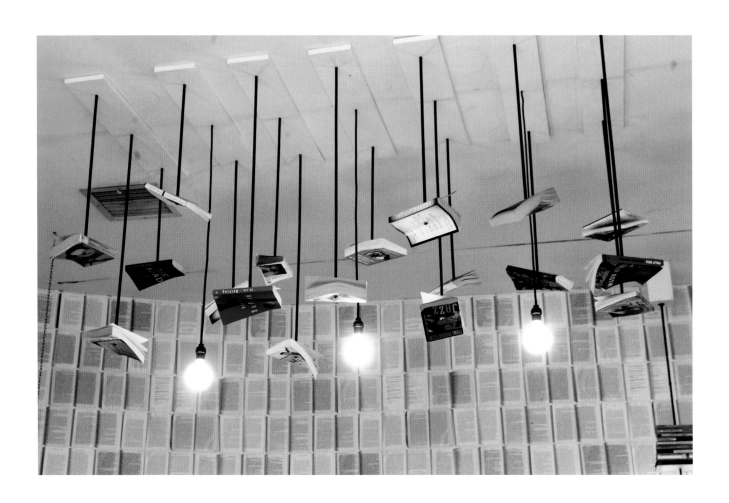

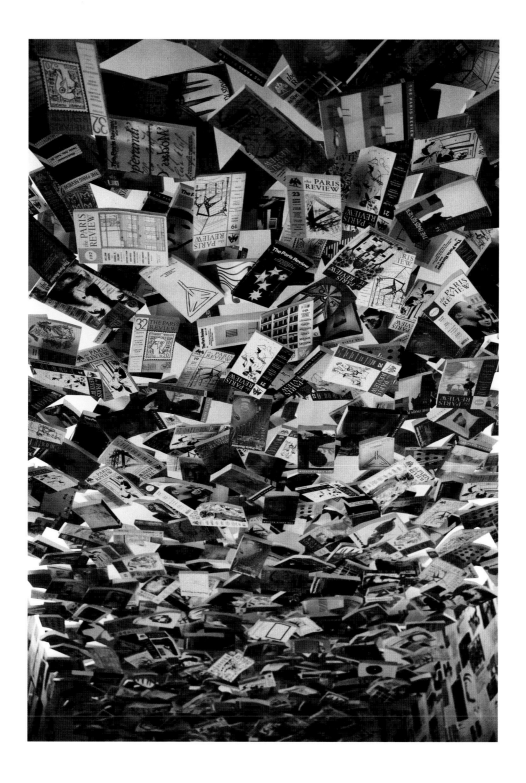

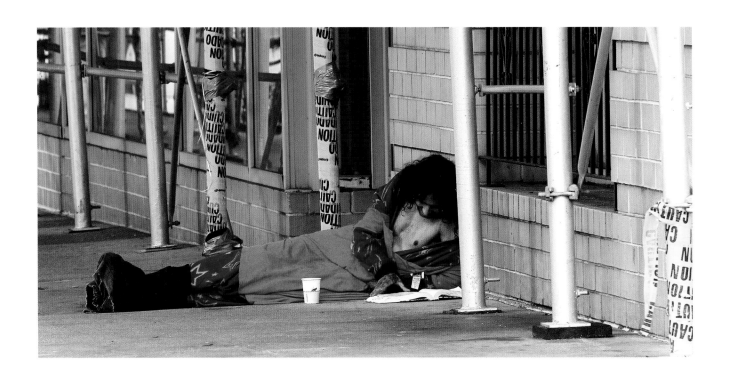

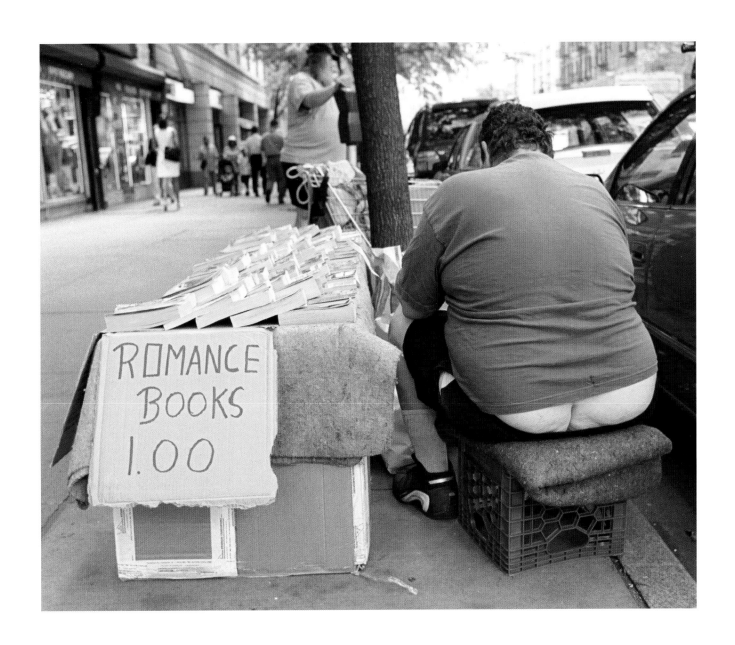

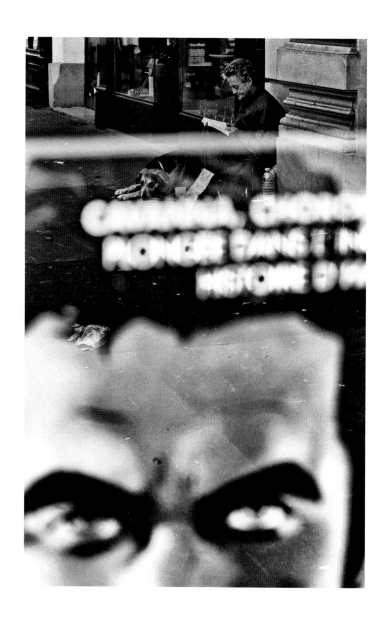

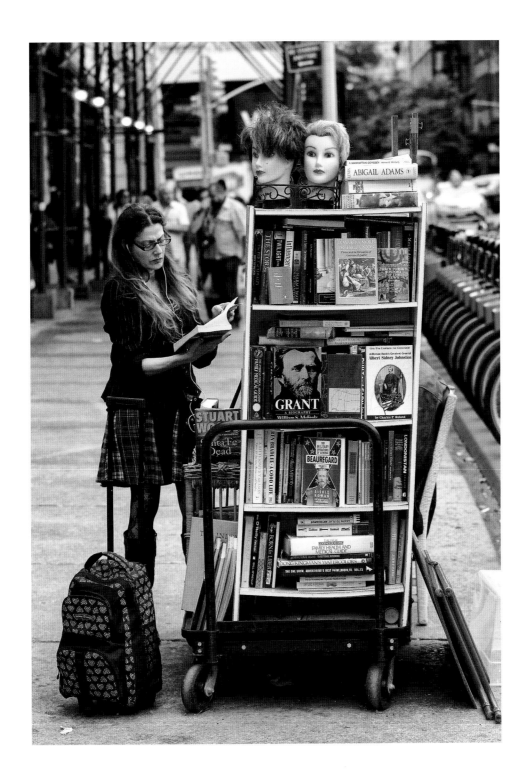

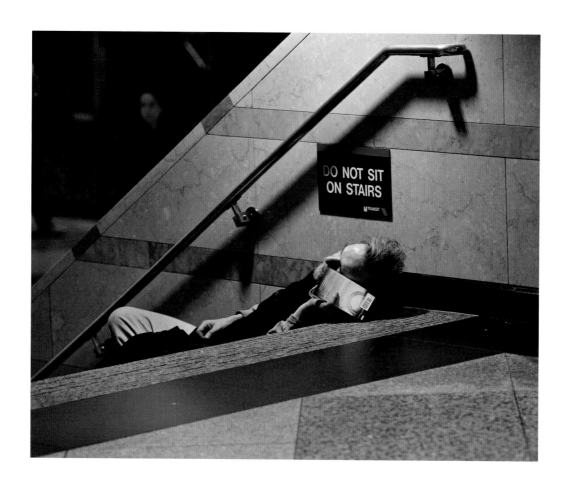

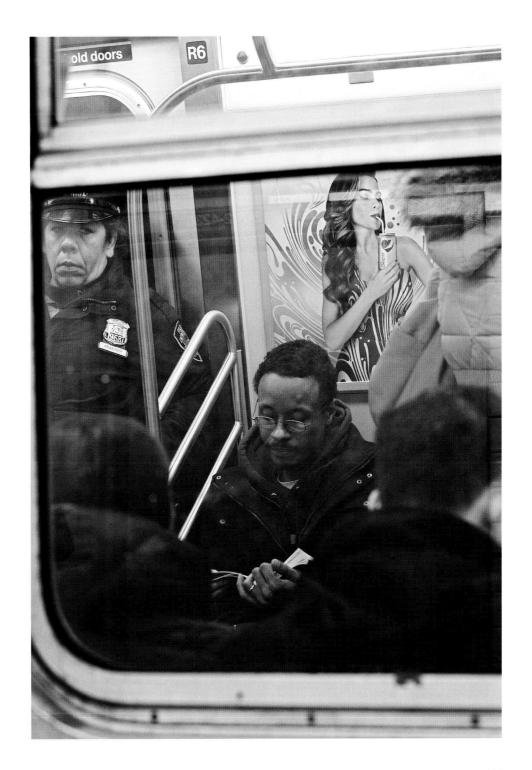

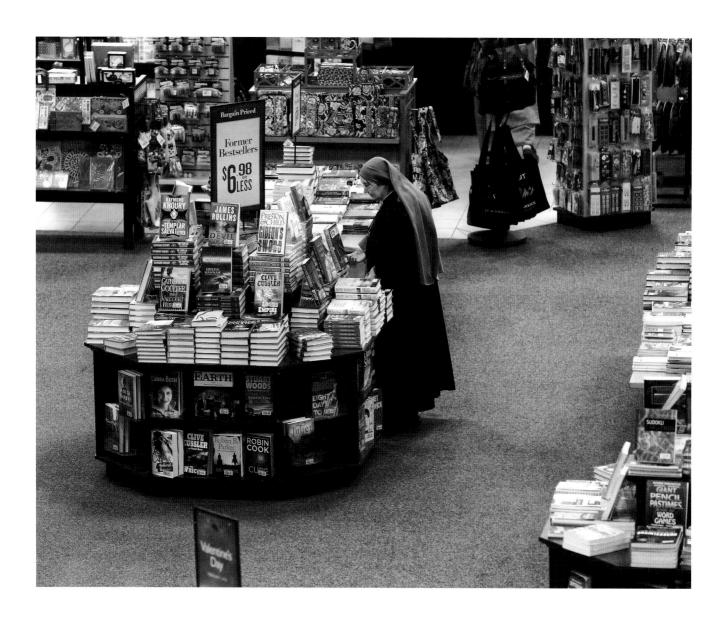

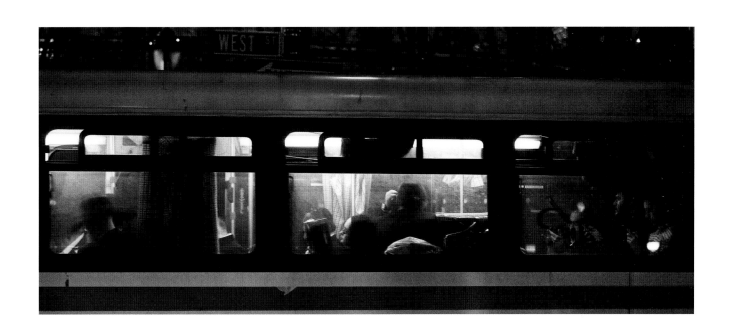

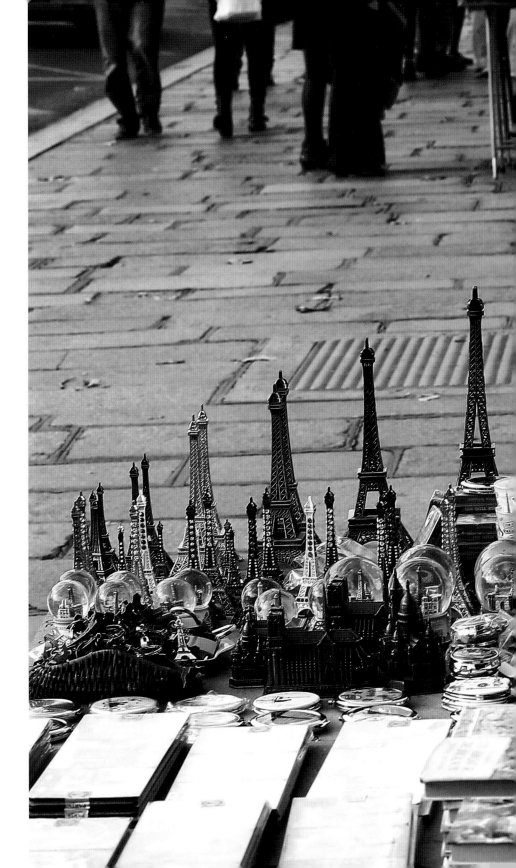

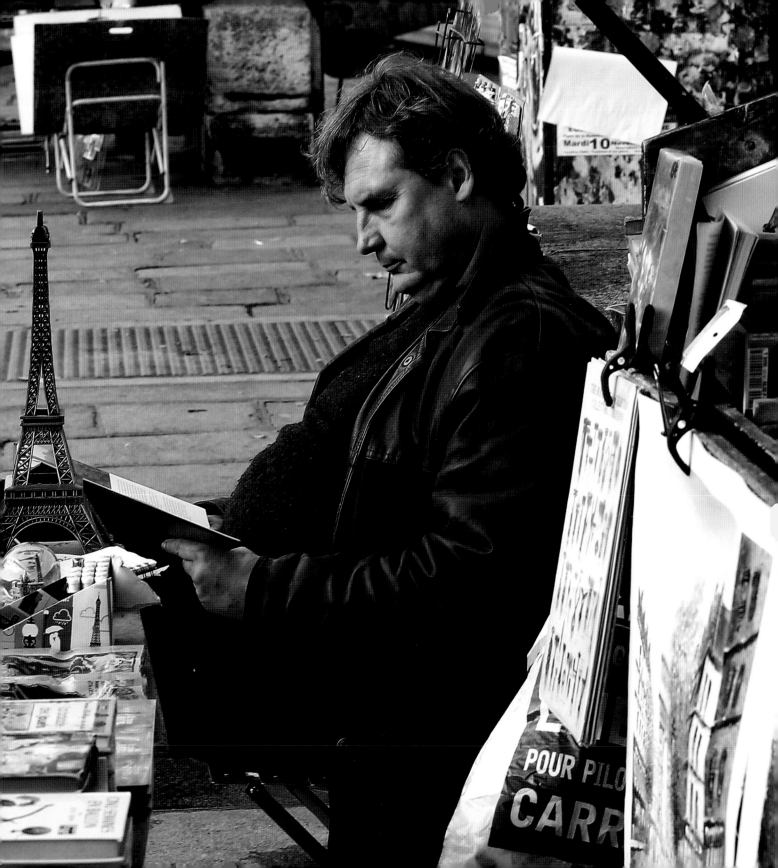

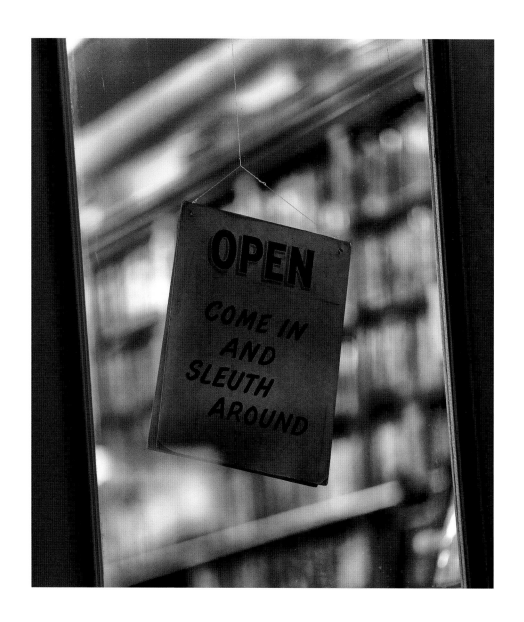

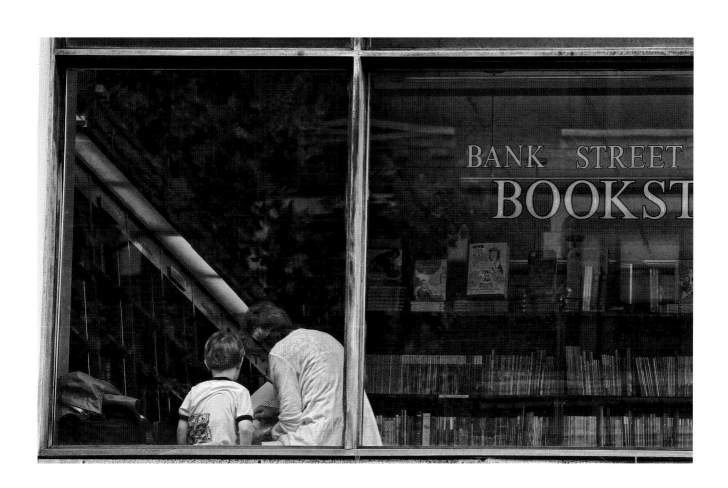

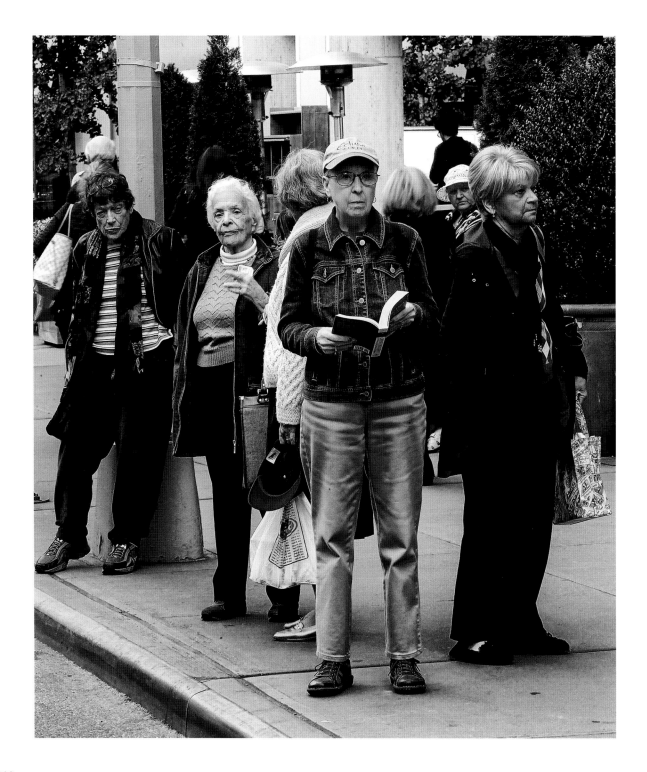

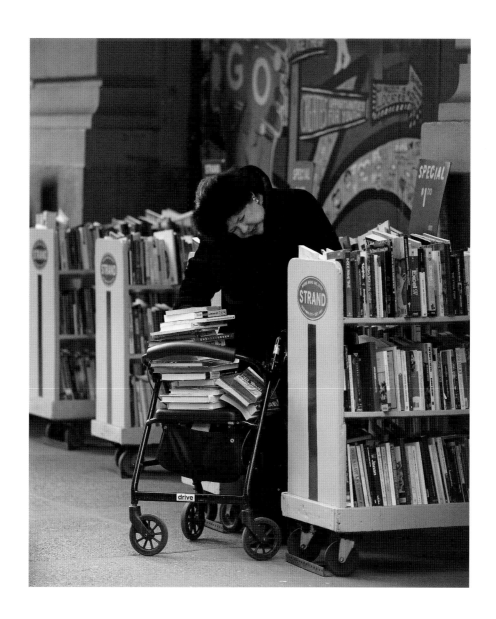

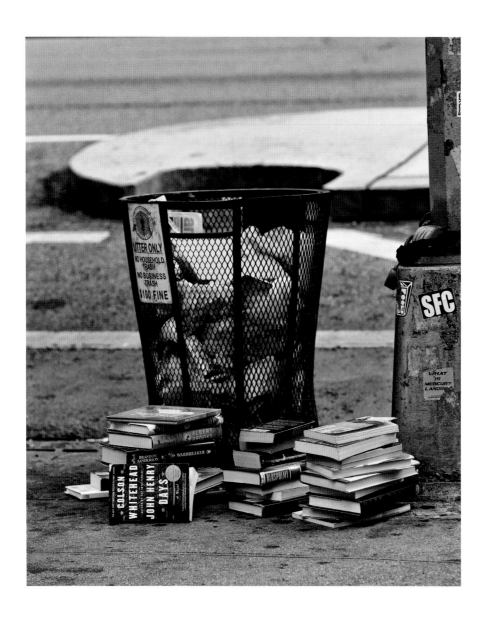

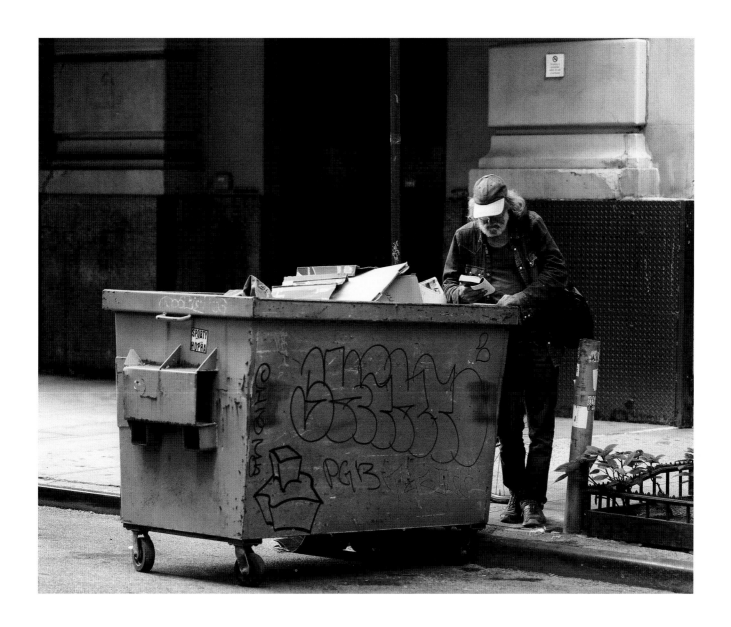

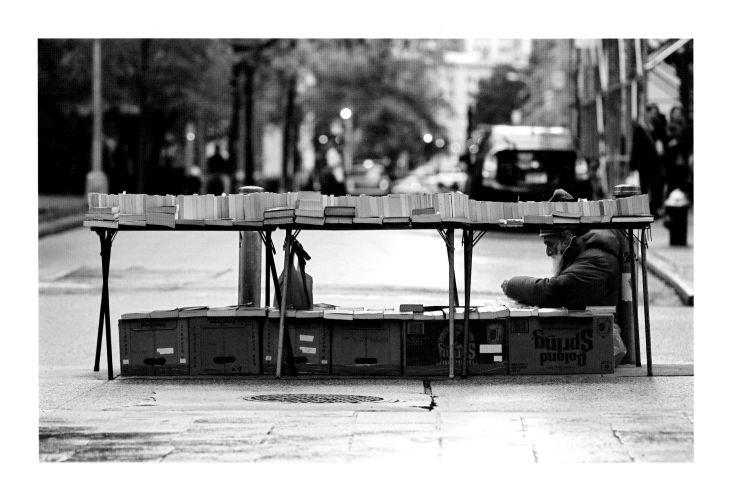

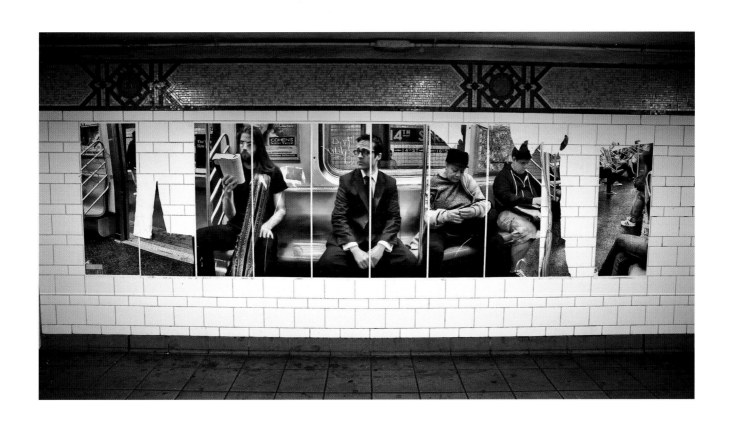

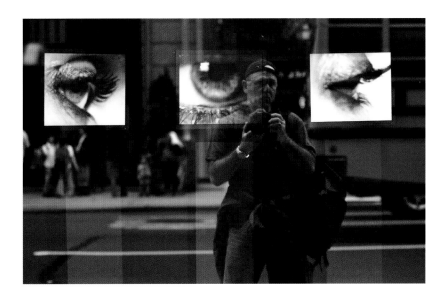

Born in New York in 1953, Lawrence Schwartzwald studied literature at New York University. He worked as a freelance photographer for the *New York Post* for nearly two decades and in 1997 *New York Magazine* dubbed him the *Post*'s "king of the streets." Books and literature have shaped several of his photo series including "Reading New York" and "Famous Poets," both self-published in 2017. Schwartzwald lives and works in Manhattan.

LIST OF PHOTOGRAPHS

5 Bus Driver, Tribeca, NYC, 2013

13 Subway Platform, 8th Street, NYC, 2014

14 Mulberry Street, NYC, 2014

15 Book Bag, Greene Street, Soho, NYC, 2015

16 Subway, NYC, 2012

17 Playground, Union Square Park, NYC, 2016

18 Montmarte, Paris, 2015

19 Amy Winehouse at Florent, Meat Packing District,
 NYC, July 30, 2007

20 2 Bros. Pizza, St. Mark's Place, NYC, 2012

21 Café, Tenth Avenue, Chelsea, NYC, 2015

22 READY FOR LOVE Bus, 104th Street and Broadway, NYC, 2013

23 "The Gift," Soho, NYC, 2015

25 190 Bowery, NYC, 2014

26 Woman on Park Bench with Balloons, Union Square, NYC, 2015

27 "STOP AGING NOW," Book Vendor, Union Square, NYC, 2013

28 Brighton Beach, Brooklyn, NYC, 2012

29 Fire Escape, Wooster Street, Soho, NYC, 2017

30 Brothers Reading Anne Rice, "R" Train, Subway, NYC, 2013

31 Antique Store, 12th Street, NYC, 2013

32 Union Square Park Playground, NYC, 2015

33 HAPPY 2 B HERE, Tribeca, NYC, 2015

34 Strand Books, 12th Street, NYC, 2012

35 Mulberry Street, NYC, 2017

37 Shoe Shine Men, 42nd Street, NYC, 2012

38 Strand Books, NYC, 2013

39 The Lover, Broadway, NYC, 2012

40 Reflection of Books on Bus, Madison Avenue, NYC, 2014

42 New York Public Library, 42nd Street, NYC, 2015

43 Broadway, Greenwich Village, NYC, 2013

44 REALITY SANDWICHES, Zuccotti Park, NYC, 2011

45 Bryant Park, NYC, 2013

46 "The Accidental Diva," Bryant Park, NYC, 2015

48 Central Park, NYC, 2012

49 Nocturne, Washington Square Arch, NYC, 2014

50 Posman Books, Chelsea Market, NYC, 2012

51 Union Square Park, NYC, 2014

52 Man pushing Stroller, 12th Street, NYC, 2012

53 Bookseller, 14th Street and 4th Avenue, NYC, 2013

54 Three Women, Washington Square Park, NYC, 2013

56 Edward Snowden, 6th Avenue and Houston Street, Greenwich Village, NYC, 2016

57 10th Avenue, Chelsea, NYC, 2012

58 I Love NY Taxi, Madison Avenue, NYC, 2013

59 West Broadway, Soho, NYC, 2012

60 Cellist, Times Square Subway Platform, NYC, 2014

61 112th Street and Broadway, NYC, 2013

62 WHERE BOOKS ARE LOVED, 2nd Avenue, NYC, 2012

63 Geisha, South Street, NYC, 2012

64 Ridgeway Diner, 6th Avenue, Chelsea, NYC, 2016

65 Umbrella Man, Subway, NYC, 2012

66 Alabaster Bookshop, 4th Avenue, NYC, 2012

67 Housing Works Café and Bookstore, Crosby Street, NYC, 2014

68 Halloween Parade, 6th Avenue, Greenwich Village, NYC, 2013

69 Broadway, Soho, NYC, 2015

70 City Hall Park, NYC, 2011

71 Washington Square Park, NYC, 2013

72 DON'T, Broadway and 12th Street, NYC, 2015

73 Barnes & Noble, 84th Street and Broadway, NYC, 2012

74 Prince Street, Soho, NYC, 2013

75 Pardon Our Appearance, Bryant Park, NYC, 2014

76 At Your Service, Strand Books, NYC, 2014

77 Edgar Allan Poe, Strand Books, NYC, 2016

78 St. Mark's Bookshop, 9th Street, NYC, 2012

79 Book Blouse, Lafayette Street, NYC, 2016

80 Book Vendor, Greenwich Village, NYC, 2012

81 Partners & Crime, Charles Street, NYC, 2012

82 Columbia University, NYC, 2013

83 Two Women on Subway, NYC, 2012

84 Book Vendor, Florence, 2014

85 Peck Slip, NYC, 2015

86 *Harlem Girl Lost 2*, Subway, NYC, 2012

87 Kids, Union Square Park, NYC, 2013

88 Window, NYC, 2012

89 New Books, Broadway and 115th Street, NYC, 2013

90 Box Kite Coffee, St. Mark's Place, NYC, 2015

91 Fleet Week, Subway, NYC, 2012

92 Triumph, Harvard Yard, Cambridge, Massachusetts, 2015

93 Battery Park City, NYC, 2012

94 Amtrak Station, Back Bay, Boston, Massachusetts, 2015

95 Mannequins, Prince Street, Soho, NYC, 2013

96 Fulton Street, Brooklyn, NYC, 2012

97 Mural, West 27th Street, Chelsea, NYC, 2014

98 Anne Hathaway, Murray Hill Diner,
Lexington Avenue, NYC, 2007

99 Carl Bernstein, ANTHRAX OUTBREAK,
Upper West Side, NYC, 2001

100 Broke, Broadway and 13th Street, NYC, 2014

101 Crouching Man, Union Square Park, NYC, 2016

102 Valentine's Day, Soho, NYC, February 14, 2015

103 Lower Broadway, NYC, 2015

104 Mattress, Soho, NYC, 2016

105 Second Story Books, P Street, Washington, DC, 2017

106 Dog Park, Tribeca, NYC, 2012

107 Turnstile, Subway, City Hall Station, NYC, 2013

108 DeSalvio Playground, Little Italy, NYC, 2013

109 Abingdon Square Park, Hudson Street NYC, 2014

110 "CASH," Avenue A, NYC, 2014

112 Lincoln Road, South Beach, Miami, 2012

113 Summer, Chelsea Park, NYC, 2014

114 Mini Mall, Bedford Street, Williamsburg, NYC, 2015

115 Reflection, Caffè Florian, Piazza San Marco, Venice, 2014

116 Yankees, Strand Books, NYC, 2015

117 Reflection, Argosy Bookstore, NYC, 2013

118 McNally Jackson, Prince Street, Soho, NYC, 2012

119 *The Paris Review*, Cosmetics Store (ceiling), Chelsea, NYC, 2014

120 Merlin, Broadway and 87th Street, NYC, 2012

121 "Crack Salesman," Columbus Avenue, NYC, 2001

122 Terror Week, Paris, 2015

123 Mannequin Heads, Book Stall, Union Square, NYC, 2014

124 DO NOT SIT, Penn Station, NYC, 2012

125 Modern Family, Subway, NYC, 2013

126 Mall, Stamford, Connecticut, 2013

127 Bus, West Street, NYC, 2016

128 Bookseller, Paris, 2015

130 Mysterious Bookshop, Tribeca, NYC, 2015

131 Bank Street Books, Broadway, NYC, 2012

132 Bus Stop, Broadway, Upper West Side, NYC, 2012

133 Strand Bookstore, 12th Street, NYC, 2014

134 Trash, 4th Avenue, NYC, 2015

135 Dumpster, 12th Street, NYC, 2014

136 Book Vendor, Washington Square South, NYC, 2013

137 DeKalb Avenue, Brooklyn Subway Overpass, NYC, 2013

139 Self-portrait, Madison Avenue, NYC, 2011

First edition published in 2018

Book design: Lawrence Schwartzwald and Holger Feroudj
Color separations by Steidl image department

Production and printing: Steidl, Göttingen

Steidl
Düstere Str. 4 / 37073 Göttingen, Germany
Phone +49 551 49 60 60 / Fax +49 551 49 60 649
mail@steidl.de
steidl.de

ISBN 978-3-95829-508-7
Printed in Germany by Steidl